紋革創生

Leather Art: Regeneration

Szu-Ti Feng

馮斯蒂

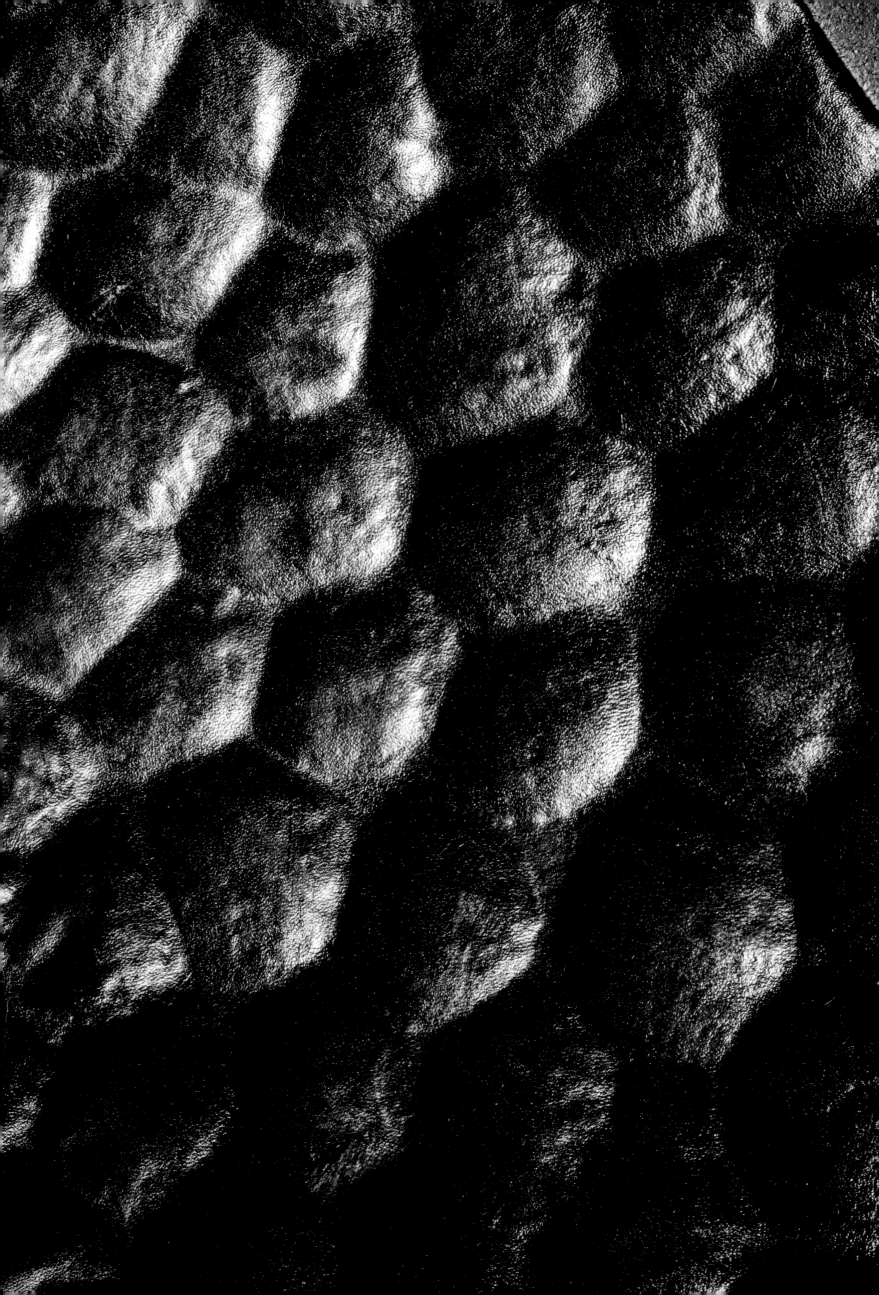

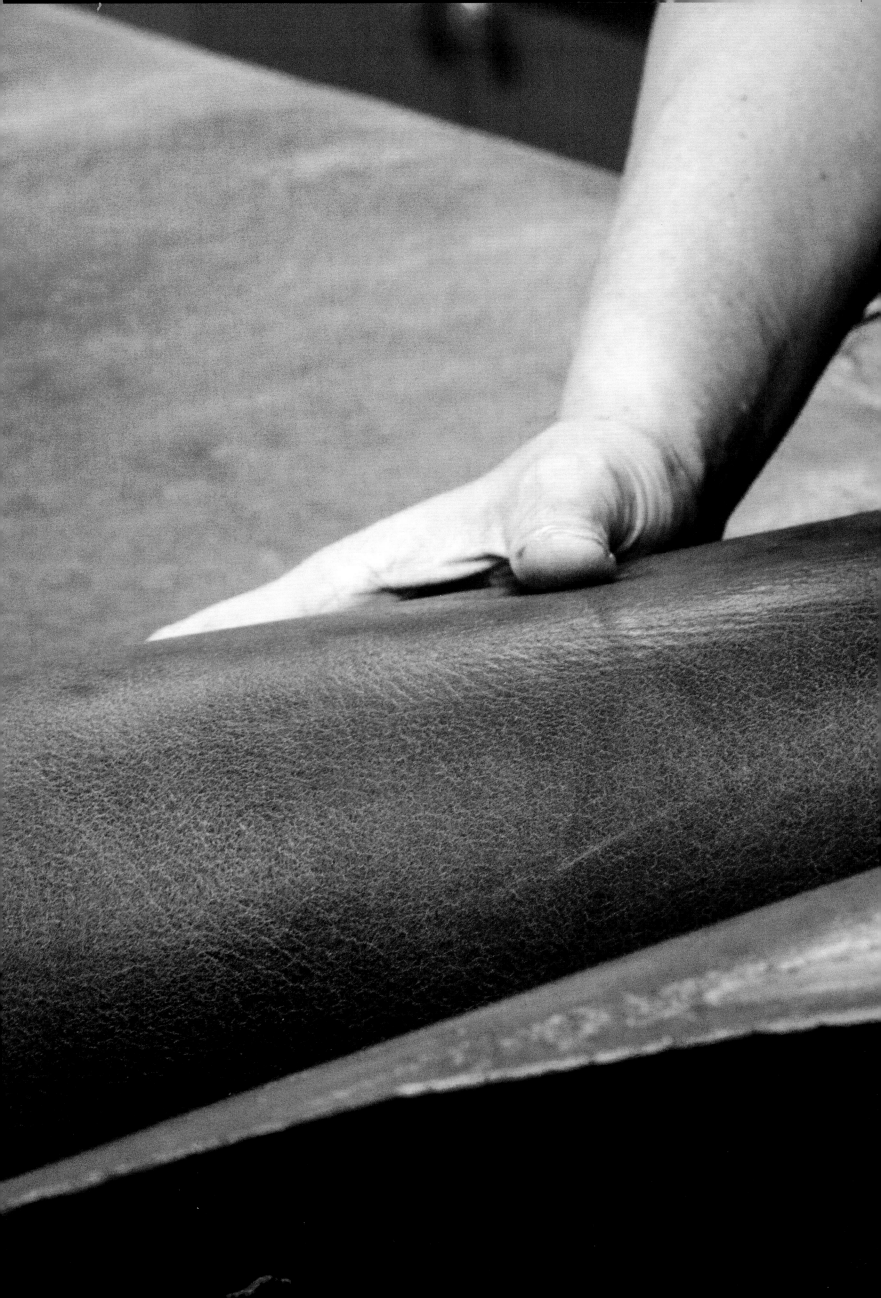

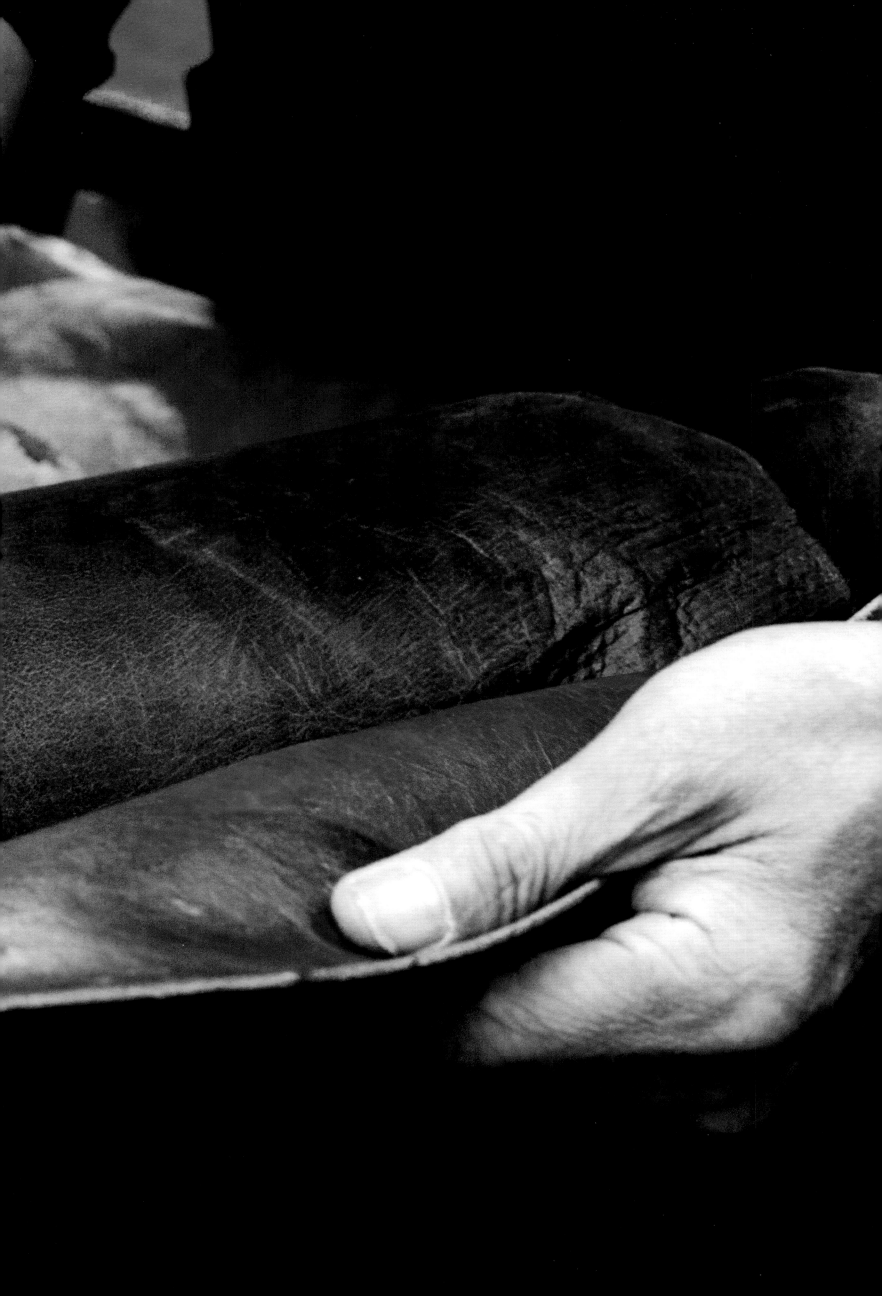

作者 / **馮斯蒂**

蒂革工舘館長
頤坊皮藝企業有限公司 創始人兼藝術總監
輔仁大學藝術學院文化創意學程 兼任助理教授
曾任 國立師範大學設計系 兼任助理教授

2019 總統府藝廊「饗宴－幸福」展出
2018 義大利 A'國際設計大獎「藝術工藝類」銅獎
　　　「紋革創生－馮斯蒂革工藝術展」文山藝廊展出
2015，2016 「寶島台灣－經典工藝」總統府藝廊展出
2014 考試院藝廊「來自心海的悸動 - 會說話的工藝」展出
2013 《工不可沒、藝不可失－漢字表意皮革工藝技法與創作研究》學術論文發表
2012 《漢字表意之皮革工藝設計意象初探》學術論文發表
2012 國立台灣工藝研究發展中心 台北當代分館「非常皮‧Fashion 工藝—皮藝的無限延伸」
　　　協辦展出
1995 紐約中華新聞文化中心台北藝廊參展
1992 台南縣立文化中心「馮斯蒂皮革藝術展」
1991 台灣工藝研究所「馮斯蒂皮革生活藝術展」
1990 台中縣立文化中心「馮斯蒂皮革藝術展」
1989 省立博物館「頤坊皮藝 '89 馮斯蒂師生展」

Author/ **Szu-Ti Feng**

Curator of Ivan Leather Gallery
Co-Founder & Design Director of Ivan Leathercraft Co., LTD, Taipei, Taiwan
Adjunct Assistant Professor, Department of Applied Arts, Fu Jen Catholic University, New Taipei City, Taiwan
Once served: Adjunct Professor, National Taiwan Normal University, Taipei, Taiwan

2019 Office of the President Republic of China (Taiwan) Art Gallery, Taipei, Taiwan
2018 Bronze A' Design Award, "Arts, Crafts and Ready-Made Design" Category, Como, Italy
2018 Solo Exhibition, Wenshen School of Special Education, Taiwan
2015, 2016 Joint Exhibition, Office of the President Republic of China (Taiwan) Art Gallery, Taipei, Taiwan
2014 Joint Exhibition, "Crafts that Speaks", Examiniation Yuan, Taipei, Taiwan
2013 Chinese Ideogram: Leathercraft Techniques Research And Innovative Work, Paper Published, Taipei, Taiwan
2012 Chinese Ideogram on Leather Craft: Design Practice and Study, Paper Published, Taipei, Taiwan
2012 Sponsor & Organizer, "Leather Art Unlimited", National Taiwan Craft Research and Development Institute, Taipei Branch, Taipei, Taiwan
1995 Joint Exhibition, Taipei Cultural Center of Taipei Economic and Cultural Office in New York, Taipei Gallery, Taiwan
1992 Solo Exhibition, Tainan County Cultural Center, Tainan, Taiwan
1991 Solo Exhibition, National Taiwan Craft Research and Development Institute, Taipei, Taiwan
1990 Solo Exhibition, Taichung City Cultural Center, Taichung, Taiwan
1989 Solo Exhibition, National Taiwan Museum, Taipei, Taiwan

作者序

　　「藝術」餵養了我成長中的靈魂，在我幼年喪母之後，轉移了我原本對母親的依賴。婚後的多重角色與壓力，並未鬆動自己對藝術的堅持；不妥協的態度，支撐了我化零為整的創作形式。藉由環境各種可能的需要，累積生活藝術化的能量，將職場上多能多功設計的養成，做為個人創作中，最佳續航的動力。時間的推移，形成個人藝術創作的特殊脈絡；不同族群的教學互動和交流，不同類項的展出和競賽，都藉以檢視自己內蘊深度與厚度；在孤寂的創作生涯，跂跂秉志前行而不悔。家庭、工作、創作與生活結合，落實革工藝術生活化。

　　「紋革創生」的概念，源於生命歷經淬煉後，呈現出一種特殊形式的生命紋路，透過不同主題，連結生活與大自然，從不同的視角和思維，以理性的感知，將傳統古典與現代時尚作感性連結。運用皮革可塑的特性，結合異材質，以多元的風格，體現於皮革上，為革工藝術創生。

　　「紋革創生」是持續創作的主題之一。以文學（文字）、循環再生、生活及傳承，從不同的角度，去演繹一個議題的深度意涵，進而連結文化、反映時代，呈現悅目實用的整合性創作。

　　「墨運」系列作品是透過創作，將已無生命跡象的乾枯樹藤，以生態循環的概念，將

其解構與皮革融合再生。讓墨韻的運力之美，在三度空間中，與空間融合呈現墨蘊張力。發展出一種感受性的容納。將文字藝術「行草」的美學特點，用新時代的手法，反映在東方印記的精神中。

「原聲曲線」作品主題之「原聲」，有洪荒初始的概念與原始的樸趣。食用豆莢與皮革融合重整再生，與生活連結成爲實用、可視、可聽的原聲樂器。臭豆除了可吃之外，更以美妙姿態轉身，化爲另一種新價值藝術。

「瑰之艷逸，儀靜體閑」，以抽象的古典文本，與當代視覺結合。將文學中蘊諭女性的特質，藉由作品多重元素的特性，從抽象文字的描繪，做具象的表達；反映一個時代生活的文化外，傳達女性韌性的無限生命力。

「群動」系列作品，在平凡中，反映了生活的事實。後疫情時代，更驗證了，不同地域的群動，令人目眩；健康、平安成爲其中最大的祝福。

「蒂・連結」系列作品的發想，來自無遠弗屆的「互聯網」概念。一段段皮革線材的交會，構成了一個串流網狀的結構。如同一張地圖，點線相連，形成社會網絡。串流連結的節點與節點間，如同社會間的各種關係脈絡；經由這些社會關係，把人們或組織串連起來，從單一人際互動發展到多種關係。

「蒂・連結」作品系列，運用單一線材隱喻「互聯網」的串流。經由非線性的節點，倍數發展；延伸隱喻並以具象形器反應現象。同時，也反應思考生命中的自我價值。連結革工藝術，積累四十多年，「傳承」成爲自我期許的當下議題；將自有的資源與教育連結，「蒂革工舘」油然而生。

「蒂革工舘」座落在起家之處，屬封閉性私人研究，教育交流、展演模擬的場域。落實「紋革創生」與生活連結，是傳承的新起點，也是據點。只爲那單純的純粹，回饋我生我長的這塊土地 -「台灣」。

Preface

Art has nurtured my soul as I grow. After I lost my mother as a child, art has shifted my dependence on her. The multiple roles and stresses following marriage have not undermined my persistence in art; the uncompromising attitude has supported my mode of creative expression by breaking down the task into small parts. Drawing upon the various possible needs in the environment, I accumulated the capacity of turning life into art, and the cultivation of multi-functional designs at the workplace has become the best driving force for my personal creations. Over time, a unique context of personal artistic creation was established; through my interactions and exchanges with different populations while teaching, along with my participation in different types of exhibitions and competitions, I examined my inner depth and strength; in the lone career of art-making, I slowly inch my way forward, holding onto my aspiration with no regret. By integrating family, work, and art-making, I am able to apply my daily life experience to leather art.

The concept of "Leather Art: Regeneration" originates from the special texture of life that is shaped by experiences, trials, and tribulations. Through different themes, the concept connects life with nature, and a sensible connection between traditional classics and conventional trends is made based on different perspectives and ideations through rational perceptions. By utilizing the plasticity of leather, combining different materials, and embodying diverse styles, leather art is regenerated.

"Leather Art: Regeneration" is one of the themes that I continue to work on. Through the different lenses of literature (ideogram), recycling and regeneration, life, and heritage, in-depth interpretations of a subject's connotation are made, which are linked to cultures and made to reflect the times, thereby presenting an artwork that integrates visual aesthetics and

practicality.

The "Ink in Motion" series follows the concept of ecological recycling through artistic creation. Withered tree vines with no signs of life are deconstructed, integrated with leather, and regenerated. The beauty of ink strokes is melded into a three-dimensional space, which creates a sense of tension and perceptible tolerance. By employing the techniques of a new era, the aesthetic characteristics of the "cursive" writing are reflected in the oriental imprint.

The "primal sound" of the theme "Primal Sound Curves" entails a primordial concept and a primitive simplicity. Fused with leather, edible pea pods are reshaped and regenerated, which are integrated with life and become a practical, visual, and audible acoustic instrument. In addition to being edible, the stink bean has made a graceful transformation into a piece of art with a new value.

"Rosa Elegancia" combines abstract classical text with contemporary vision. By employing the features of multiple elements, the characteristics vested in women by literature have been transformed from the depiction of abstract text into concrete expressions; in addition to reflecting the living culture of an era, the piece also conveys the infinite vitality of women's resilience.

The "Collective Sensing" series reflects the facts of life in the ordinary. In the post-pandemic era, it has been further proven that the collective sensing in different regions is fascinating—good health and safety has become the greatest blessing.

The "STi's Web" series was inspired by the boundless concept of the "Internet of Things." The intersecting sections of leather constituted a streaming web-like structure. Just like a map, the dots and lines are connected to form a social network. The interconnections between the nodes in the streaming web resemble the various relationships in the society; from a single interpersonal interaction to the development of a wide variety of relationships, people or organizations become connected through these social relationships.

The "STi's Web" series uses a single wire as an implicit metaphor for "Internet of Things" streaming. Through non-linear nodes, the network grows exponentially; while the implicit metaphor is extended, a figurative apparatus is employed to reflect the phenomena. At the same time, the series also represents my reflection on self-worth in life. Having been connected to leather art for over forty years, "cultural continuity" has become the topic of my current self-expectation; by connecting my own resources with education, Ivan Leather Gallery has sprung into existence.

Ivan Leather Gallery is located at where I started up. It is a platform for closed private research, educational exchange, and exhibition simulation. Integrating the connection between "Leather Art: Regeneration" and life is not only the new starting point, but the stronghold of continuity. Just for the sake of pure simplicity, and to give back to the land where I was born and raised—Taiwan.

About

The precursor of the Ivan Leather Gallery is the family home and start-up location of leather artist Szu-Ti Feng; it is a venue for closed private research, educational exchanges, and exhibition simulation. It connects with life through the notion that only creative changes can revolutionize leather art. Moving forward by continuing to innovate and evolve is the new starting point and stronghold for art creation.

關於

「蒂革工舘」源於革工藝術家 馮斯蒂女仕起家之處，屬封閉性私人研究，教育交流、展演模擬的場域。以惟有創意的變革，才有革變的創藝，與生活連結。朝創變新的藝脈前行，是新的起點也是據點。

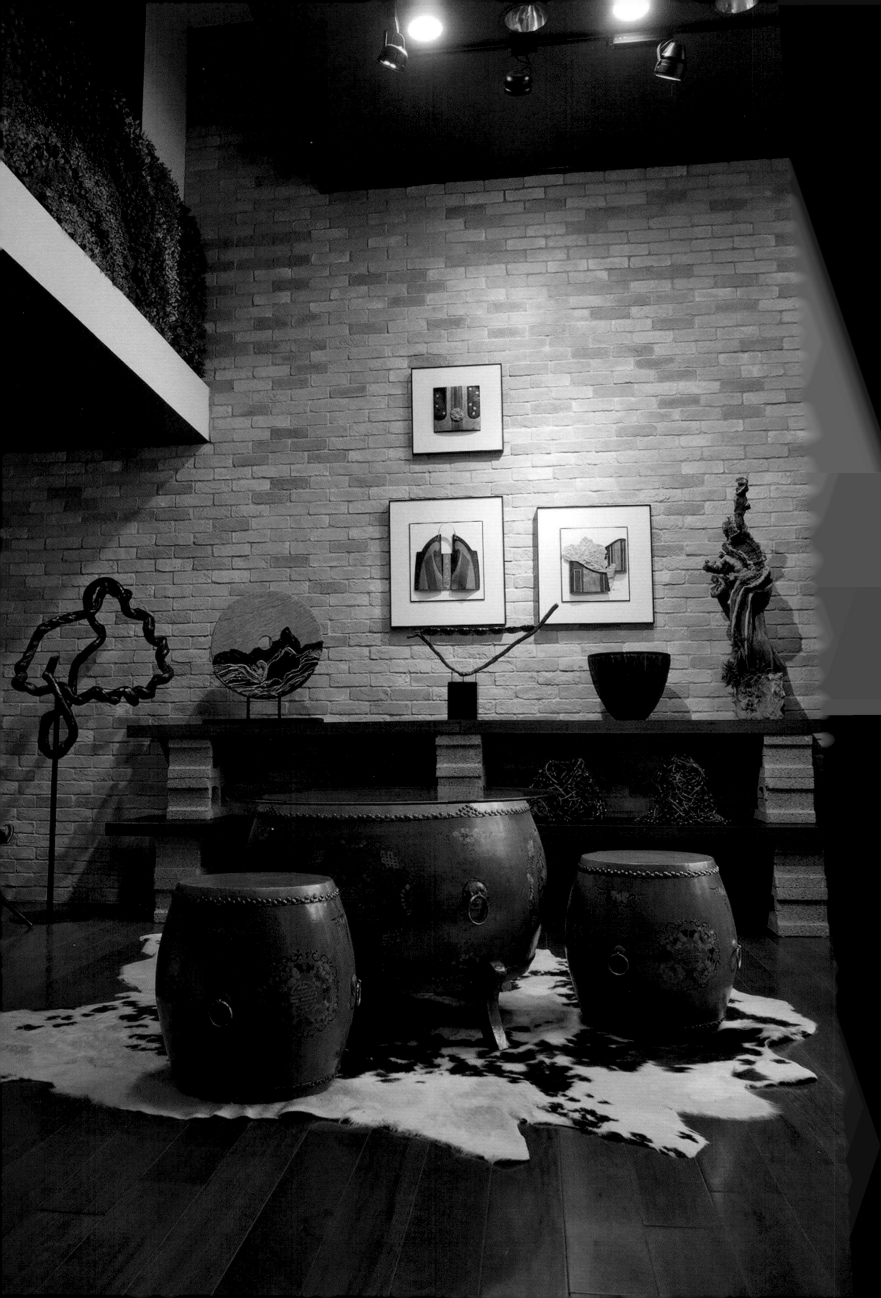

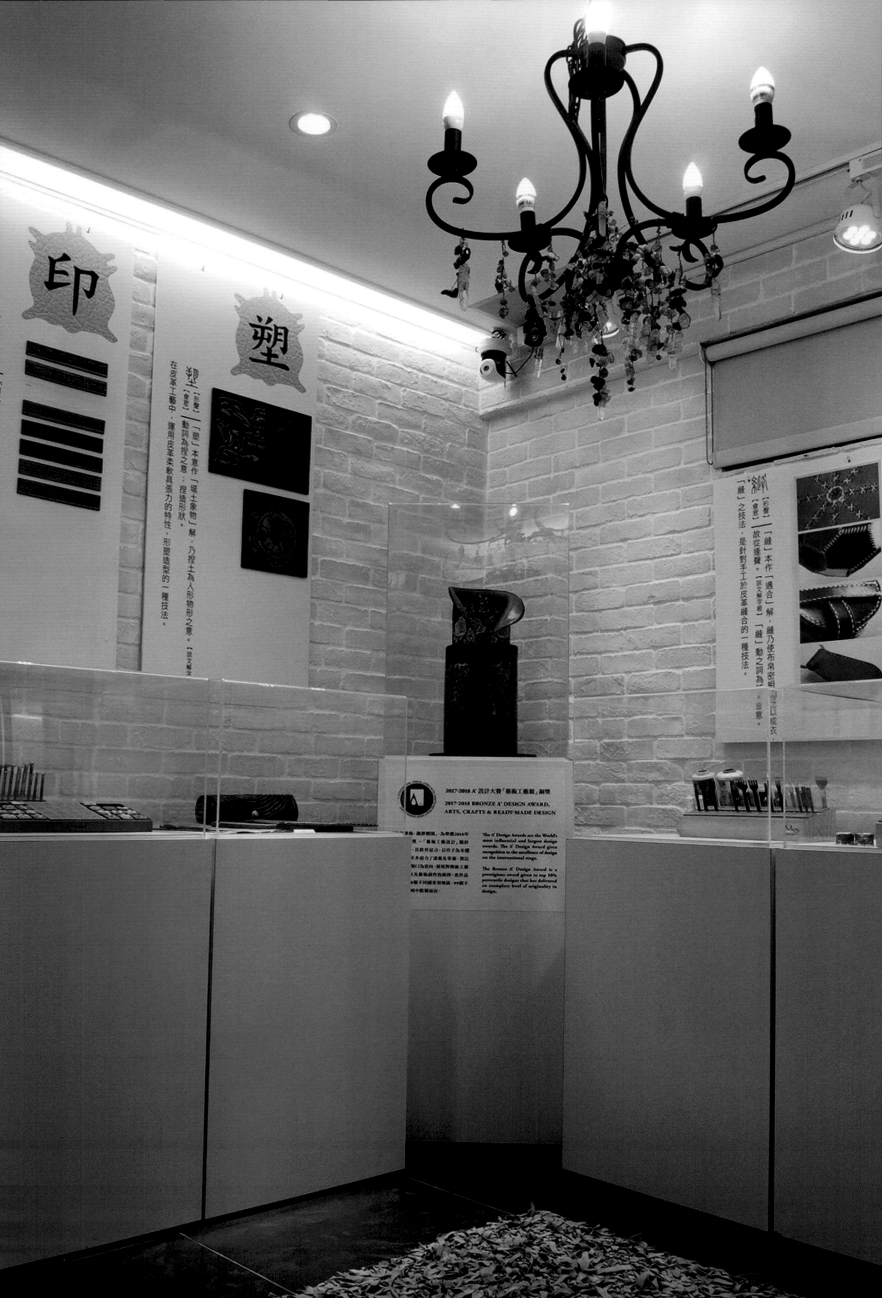

斯革創變新藝脈，蒂聯萬象藏大千

Szu-Ti started a new leather art lineage through her innovation and revolution. She built an intricate web connecting life and nature.

Grass Roots &
Thriving

Through providing stimulation and development
outside of school education, we have enhanced
the possible nutrient for creativity for students at
different stages. Choosing the appropriate grass root
education, creating opportunities to experience and
explore, and providing guidance before letting go
and becoming their companions is a crucial purpose
for the development and continuation of the "Leather
Art: Regeneration" exhibition.

根深・葉茂

各個不同階段的學子，藉由學校教育外的刺激與開拓，增強創作中可能的養分。選擇適性的根深教育，經由體驗、探索、引導，進而放手與陪伴，是「紋革創生」革工藝術展，發展延續重要的意義。

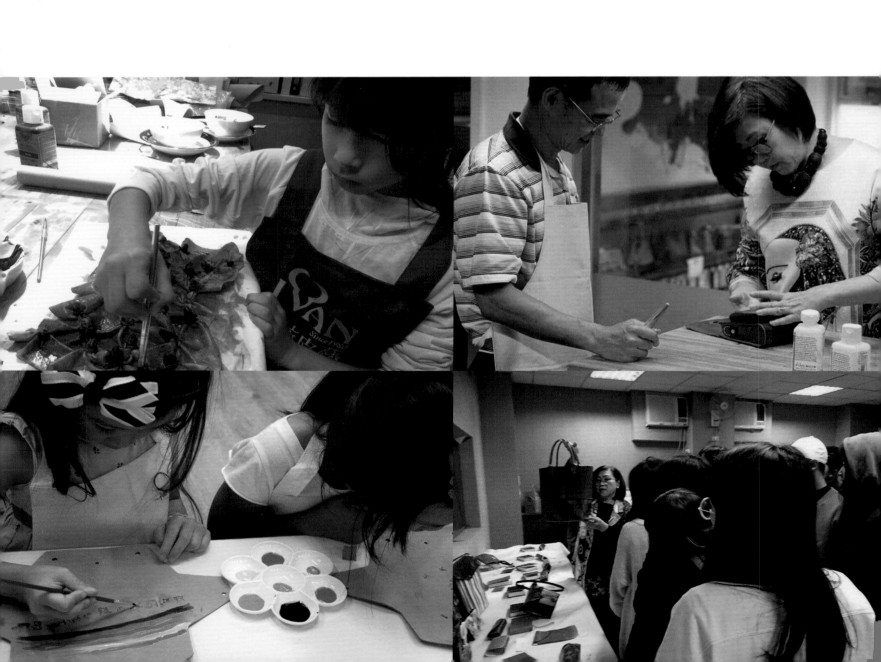

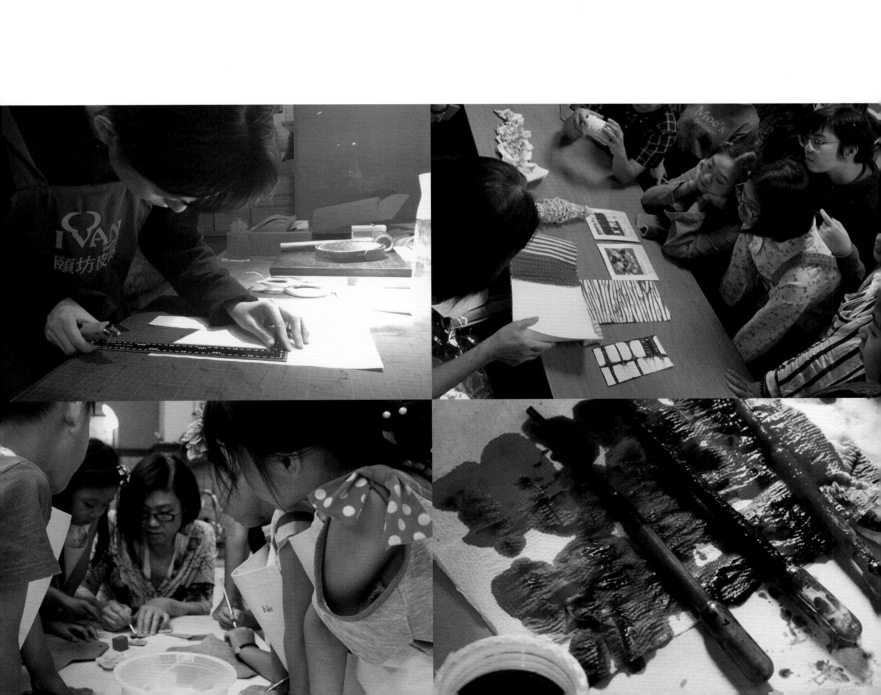

Companionship

In special education, "companionship" is not a simple term. The faculty (14 teachers led by the principal) helps the student thrive through resource input, sharing, interactions, experience, and discussions, thereby materializing companionship with love, in hope that the special education leathercraft program would blossom one day...

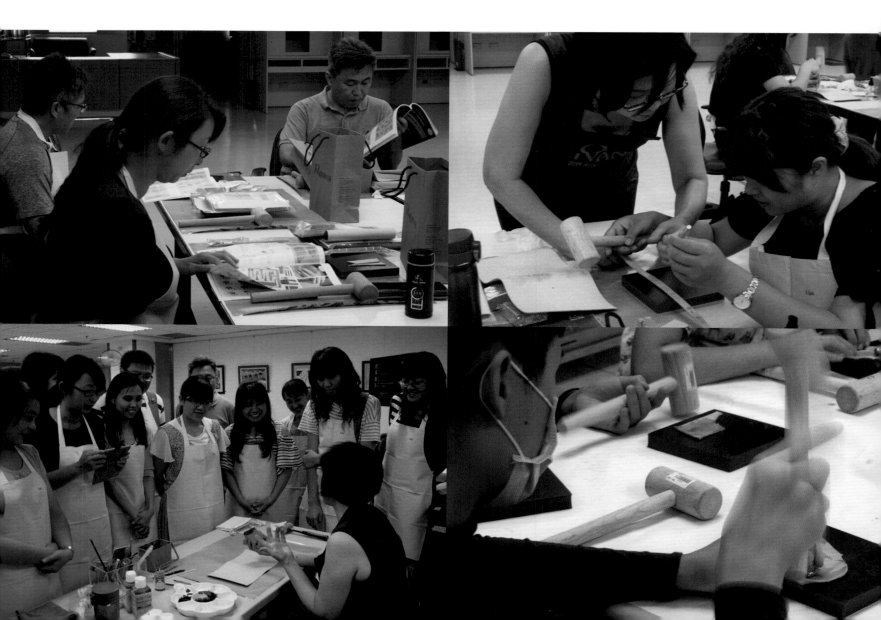

陪伴

在特殊教育中，「陪伴」不是一個單純的名詞。

從注入資源，分享、互動、體驗、研討落實助飛（由校長領軍 14 位老師參與）。踏實了愛的陪伴，期待特教的革工藝術教育，有開花的一日⋯

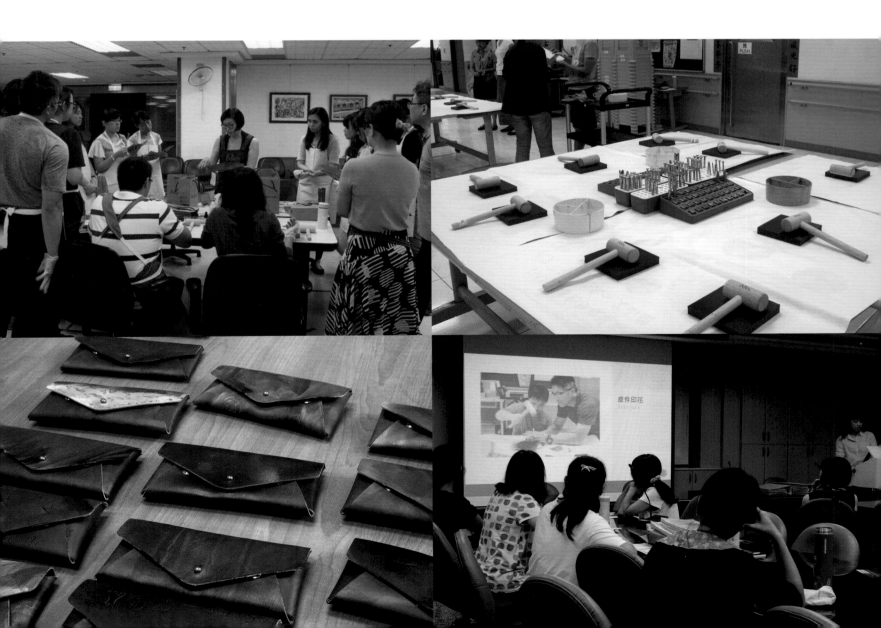

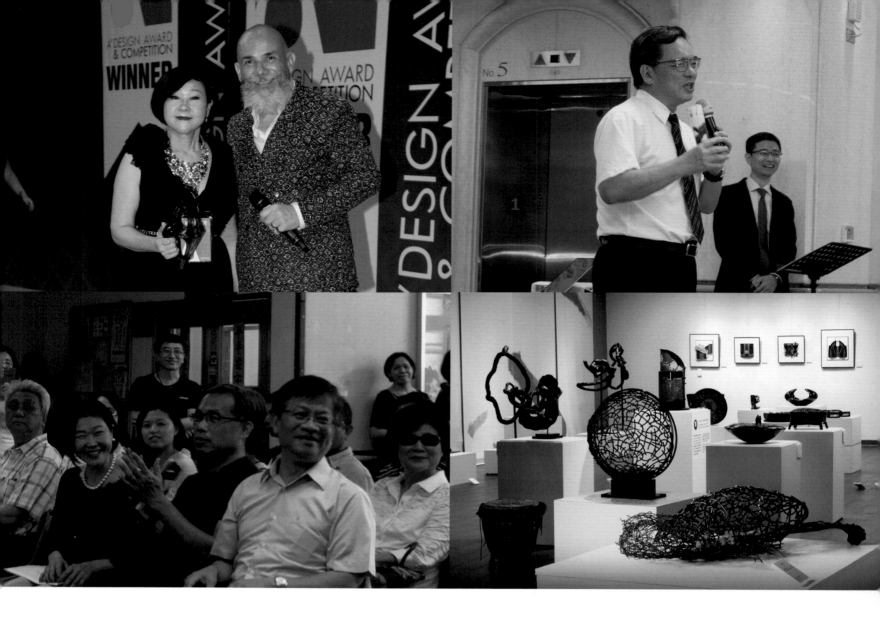

Exhibit

The initial exhibition of "Leather Art: Regeneration" was held at Wenshan School of Special Education from May 21 to June 27, 2018. Drawing upon different themes and ideas, we linked education with the environment, nature, and life. We shared our experiences through the exhibition and activities. In addition to supporting the staff of special education with our actions, we also incorporated resources from our enterprise and connected them with special education by having the students watch, emulate, and observe hands-on experiments. We also offer suggestions through our discussions and exchanges with the teachers, in hope to increase the possible benefit of leathercraft education on the mental and physical rehabilitation of the "slow-flying angels."

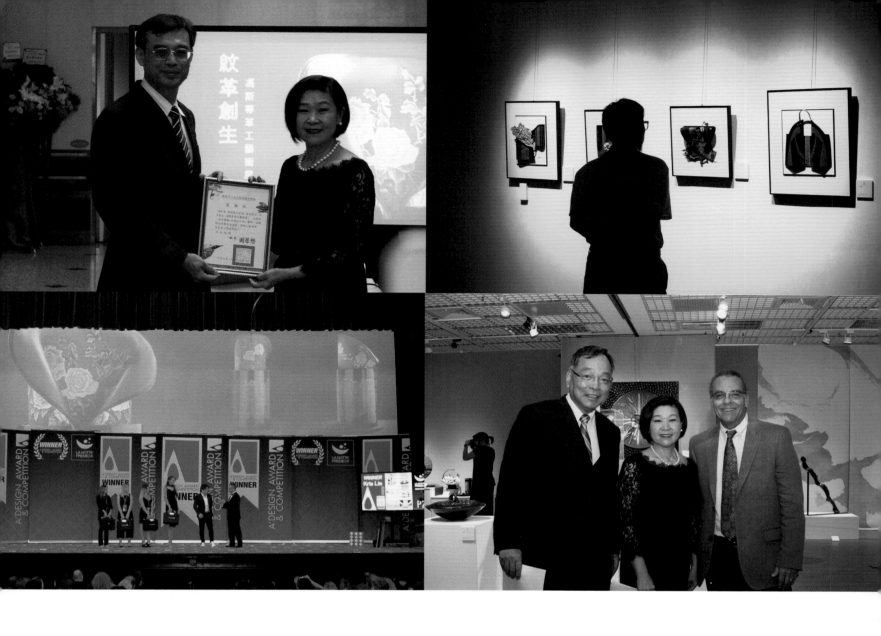

展覽

「紋革創生」初探，已於 2018 年 5 月 21 日至 6 月 27 日在文山特殊教育學校完成。藉由不同主題思維，連結教育、環境、自然與生活。

透過展覽、活動分享經驗，用行動支持特教工作者外，引進自有企業的資源，從觀摩與觀察實作實驗中，與特殊教育連結。經由跟老師群的討論交流提出建議，讓革工藝術教育，對「慢飛天使」的孩子們，在心靈與肢體復健上有助益的可能。

There are many ways to present "leather art." "Carving" is a form of creative expression that interprets the artist's ideology on the surface of vegetable-tanned leather by using special rotating carving knives and auxiliary tools.

The color "red" has permeated all levels and fields of the Chinese society. Symbolizing passion, celebration, suspiciousness, marriage, and good fortune, it has become the background color of the profound Chinese culture throughout history. When the mindset for life, color, and mode of creative expression are synergized, the single value is no longer simple, and a meaningful cultural depth is achieved

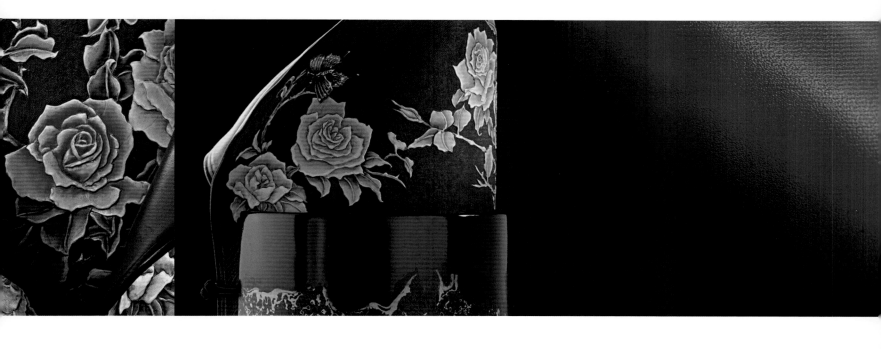

「革工藝術」有多種呈現的風格。

「雕」是一種藉由特殊旋轉雕刀和工具,在適當含水軟化的植鞣革面上,詮釋創作者思維的一種表現形式。

「紅色」浸蘊在華人社會中的各個層面與領域,成爲華人深厚文化的底色。貫穿了華夏的歷史,象徵熱情、喜慶、吉祥、婚嫁與好運。當生活的思維、色彩與創作形式結合,單一的價值,不再單純,進而產生了具意義的文化深度。

The use of "totem" is one of the earliest forms of clan culture in human history. The integration of life and totem presents symbolic meanings and stunning patterns of transformation.

The concept of colors, the homophones of words, the styles and elements, and the allegories and metaphors have all shaped the story of overflowing life and fortune.

By using words, the revolution in the brain extends thoughts and showcases the texture of life's trajectories.

The melody surging in the brain collides with the classical and the contemporary. The accumulation of the process becomes a source of creation, which is illustrated by the unique textures.

「圖騰」的運用，是人類史上最早的一種氏族
文化。生活與圖騰結合，呈現了象徵的寓意
及令人驚嘆的變身紋路。

色彩的概念，文字的諧音；造型和元素，寓
意及譬喻，牽引了滿溢的生命故事。

腦內的的革命，藉由文字延伸思想，呈現生命
軌跡的紋路。

腦內激盪的旋律，碰撞古典與當代。過程的
積累，成爲創生之泉，呈現於特有的紋路中。

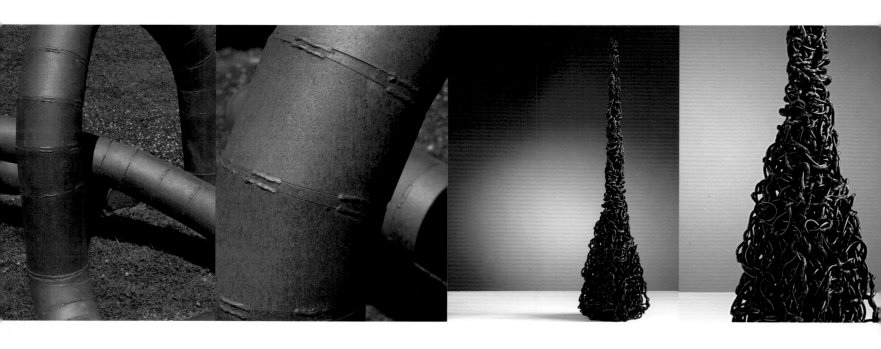

目 錄　　*CONTENTS*

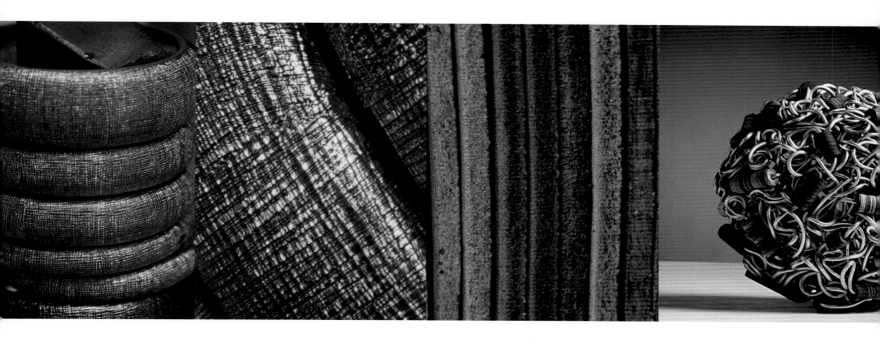

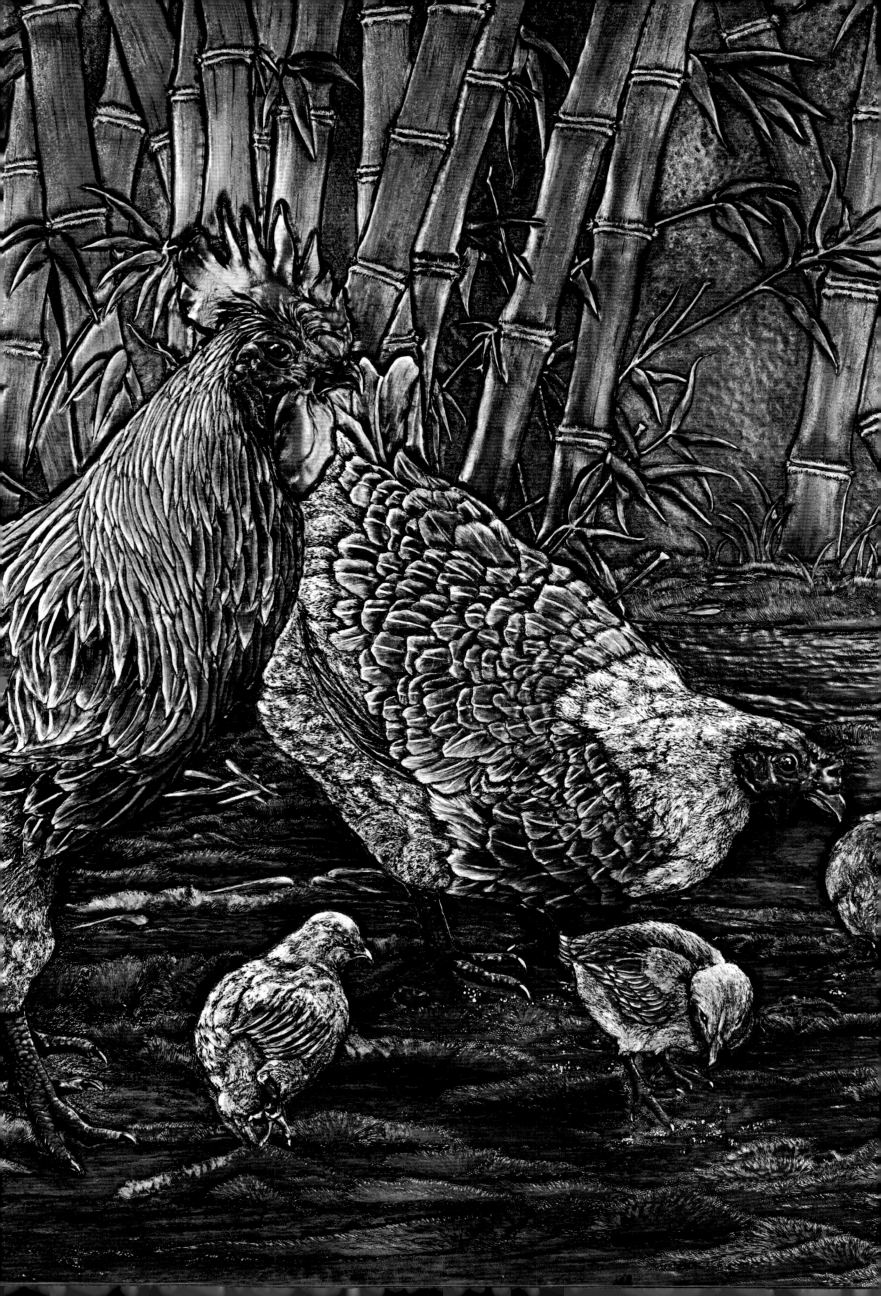

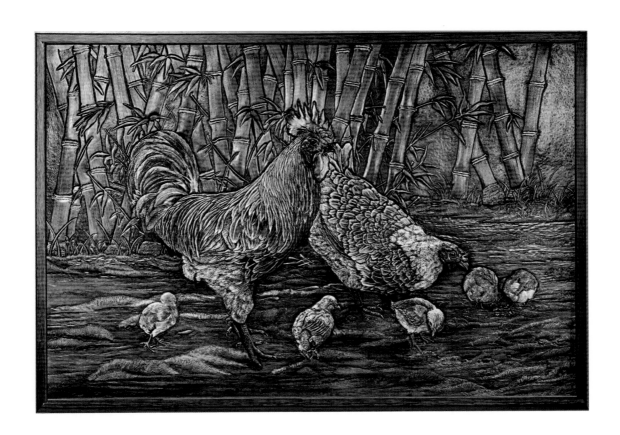

The Beginning[*]

"Chicken" is a partial homophone of "home" in Hokkien. "Home" is a heartwarming place—it is a resting station for the soul.

The gathering and amity among the chickens not only symbolizes the beauty of family harmony, but also tells the story of how to start a happy family.

* This title has multiple connotations for the artist. "起家," the original Chinese title, literally means to start a family, or to start a business. The artist turned her first family home into a gallery, and this was also where she started her business; thus, "起家" marks the beginning of not just a family, but also a business and career

起家

「雞」的閩南語諧音爲「家」。

「家」是一個溫馨的地方，是每個人心靈的驛站。

雞群的聚守與祥和，寓意了全家和諧之美。更述說了幸福的起家之道。

起家　The Beginning
130cm x 98cm x 6cm

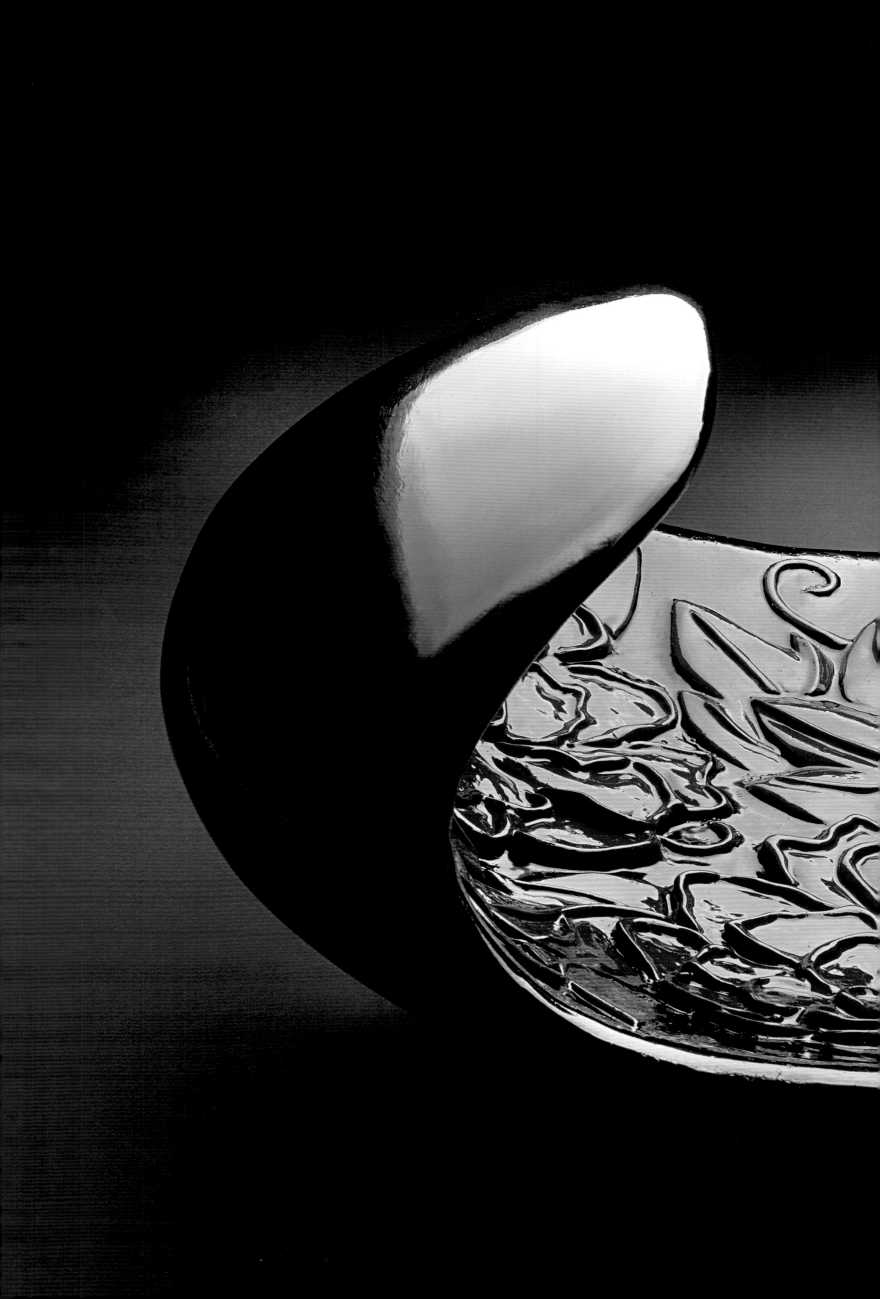

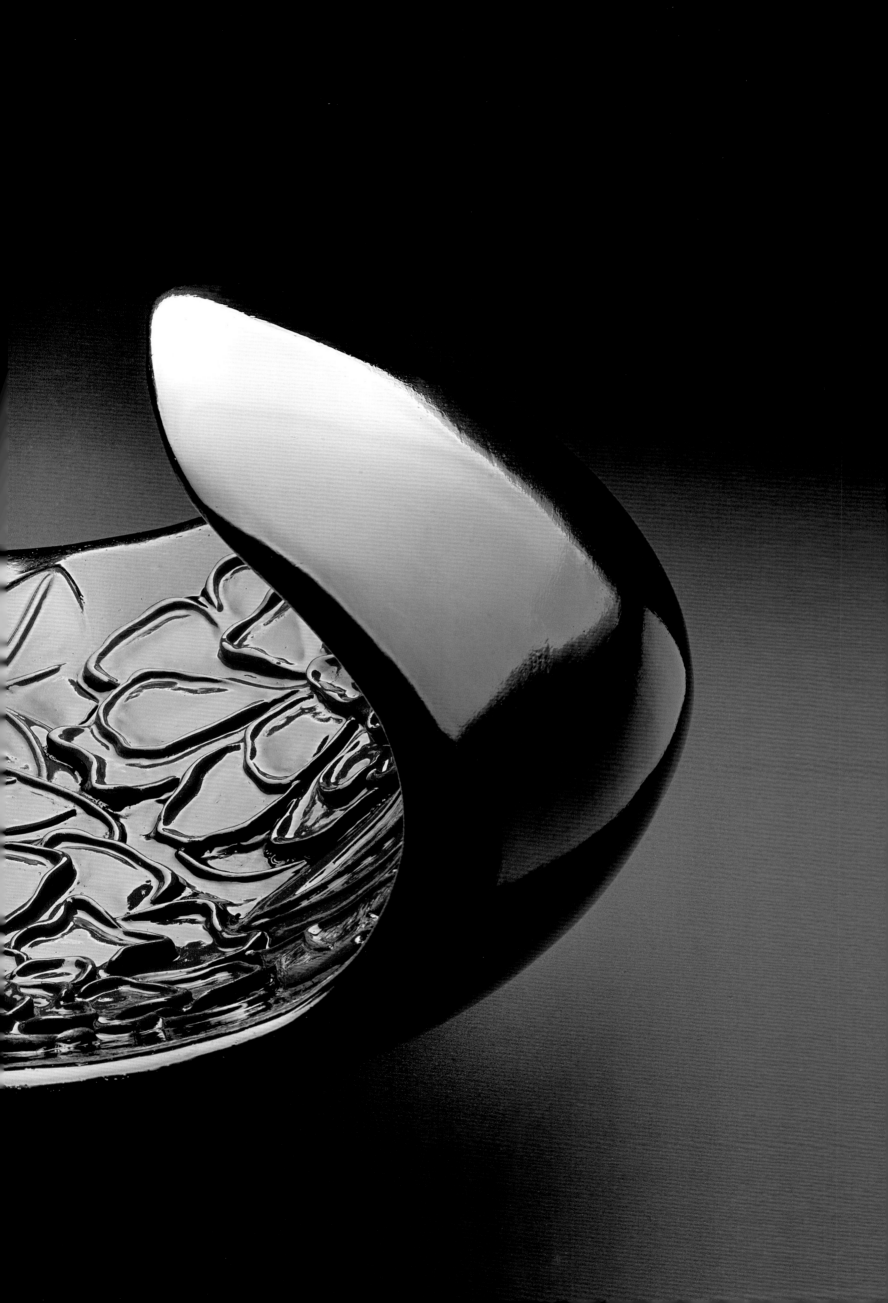

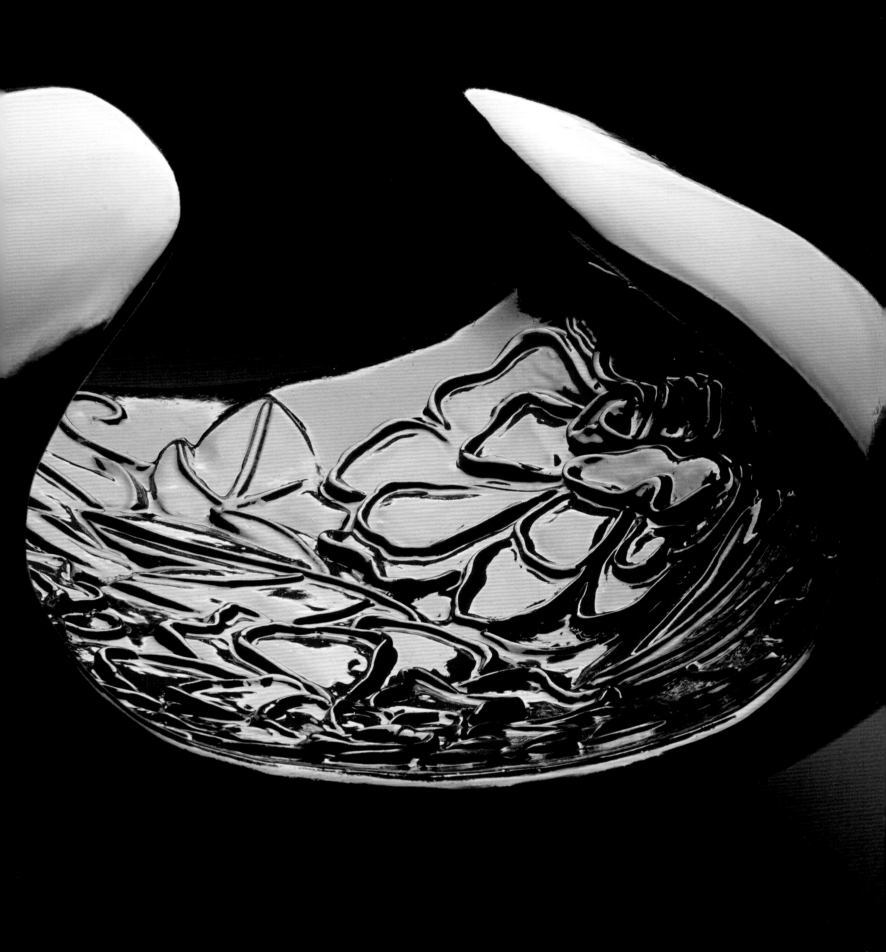

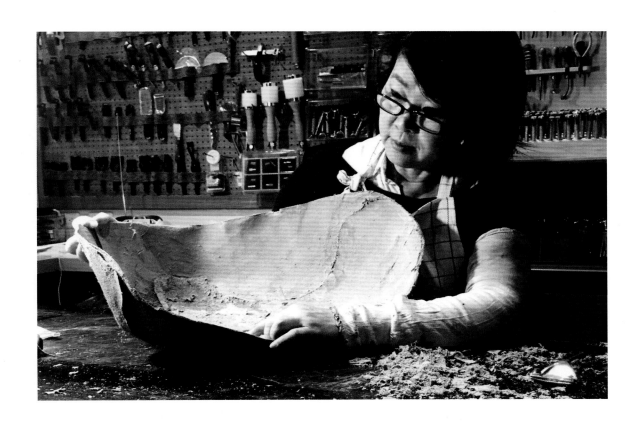

The Love Within

Blooming passionately, the embossed flowers synergize with the simple shape that resembles a fist and palm salute, revealing the pure love in the heart.

心中有愛

盛開熱情的浮雕花卉，與微合作揖的純粹外型結合，呈現純淨內蘊的心中之愛。

心中有愛 The Love Within
47cm x 38cm x 26cm

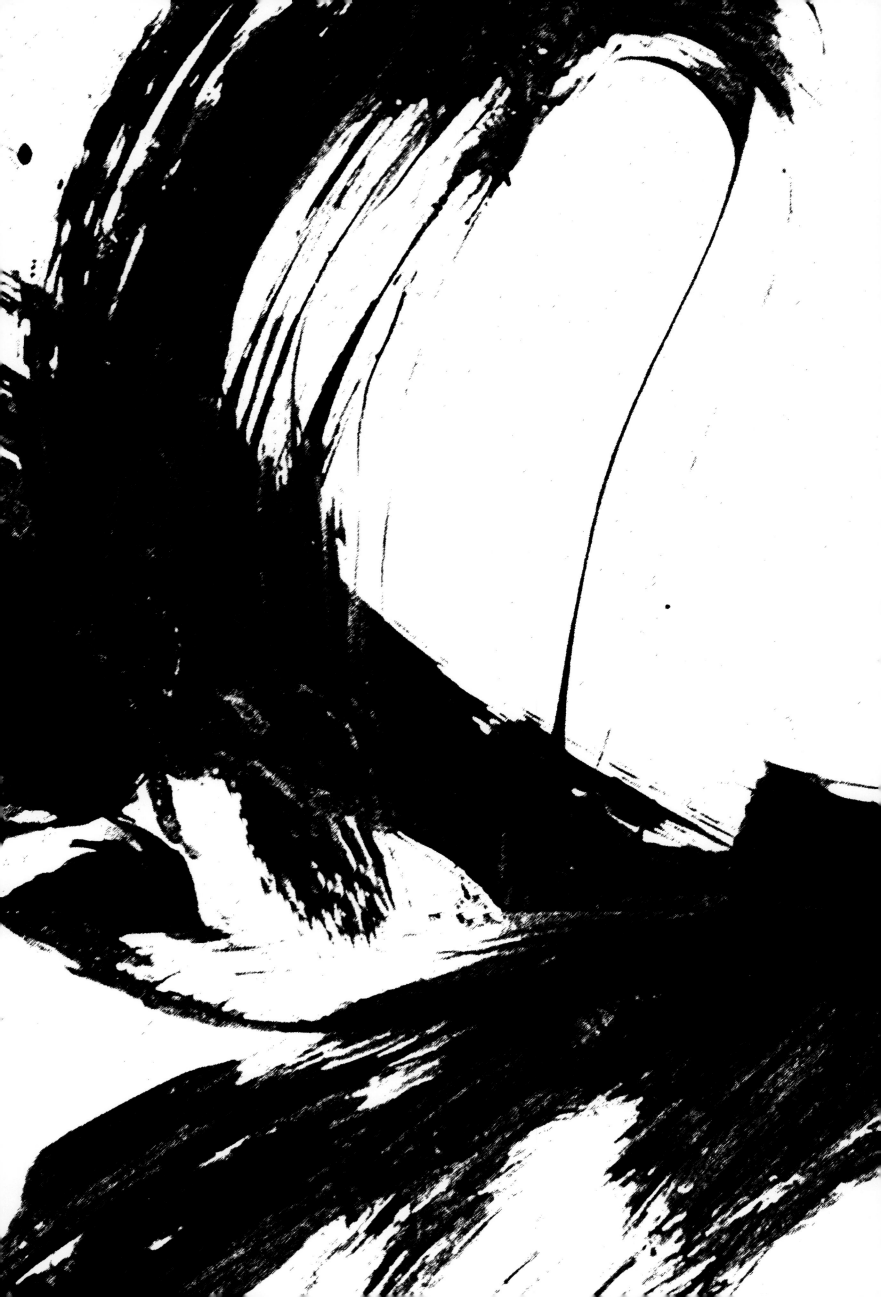

墨運

「文字」是一種符號，代表語言，也是文化。
在華人久遠的歷史發展過程中，「書法」鮮明
的特色，形成了獨幟一格的民族藝術。

書法中的「行草」具書寫與繪畫的美。「行草」
文字是否可以從平面的載體走出？激發了創
意思考靈感的來源···

Ink in Motion

"Ideograms" are a type of symbol that represents
language; it is also a culture. In the long course of
history of the Chinese, the distinct characteristics of
calligraphy have created a unique cultural heritage.
The cursive style in calligraphy bears the beauty of
writing and painting. Can the cursive characters come
out from the two-dimensional vehicle? This question
sparked the inspiration for creative thinking…

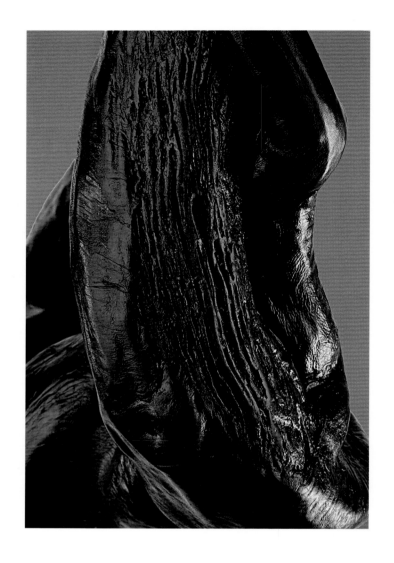

Using leather as a medium while fusing tree vines with tree lacquer, the artist has integrated part of the concept of "ink in motion" in cursive writing with life and nature; the natural beauty and texture of the piece can also be treasured.

以皮革爲載體融合樹藤與樹漆，將「行草」墨運中的片段概念，連結生活與大自然；自然的美感和肌理也可以被珍藏。

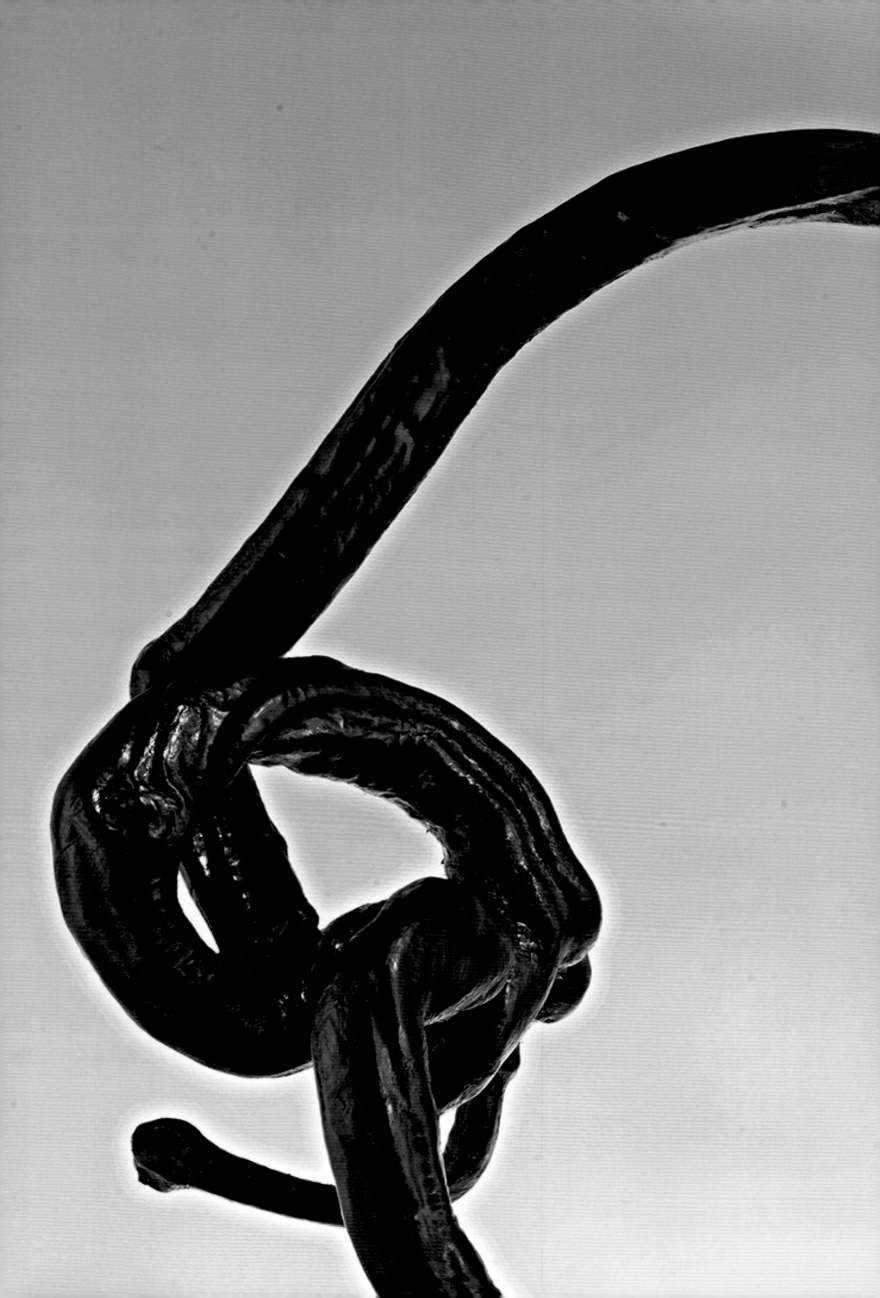

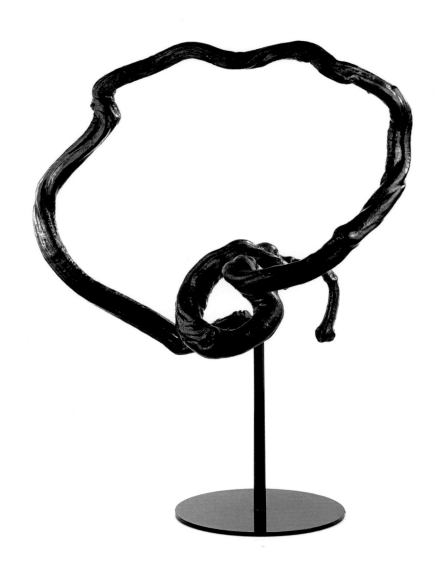

The tree vines serve as a medium, which is fused with leather and melded with tree lacquer. The graceful appearance of cursive writing is displayed through different structures from multiple perspectives in the three-dimensional space of each piece; in the attempt to demonstrate the beauty and tension of the ink's motion, achieving a balanced footing through the principle of leverage presents yet another challenge.

以樹藤爲介質,與皮革複合與樹漆融合。在「行草」優美姿態中,呈現多視角的不同結構,不同作品的三度空間;藉由槓桿原理,取得作品立足的平衡,爲墨韻運力之美、張力呈現的另一種挑戰。

墨運(一) Ink in Motion I
92cm x 33cm x 62cm

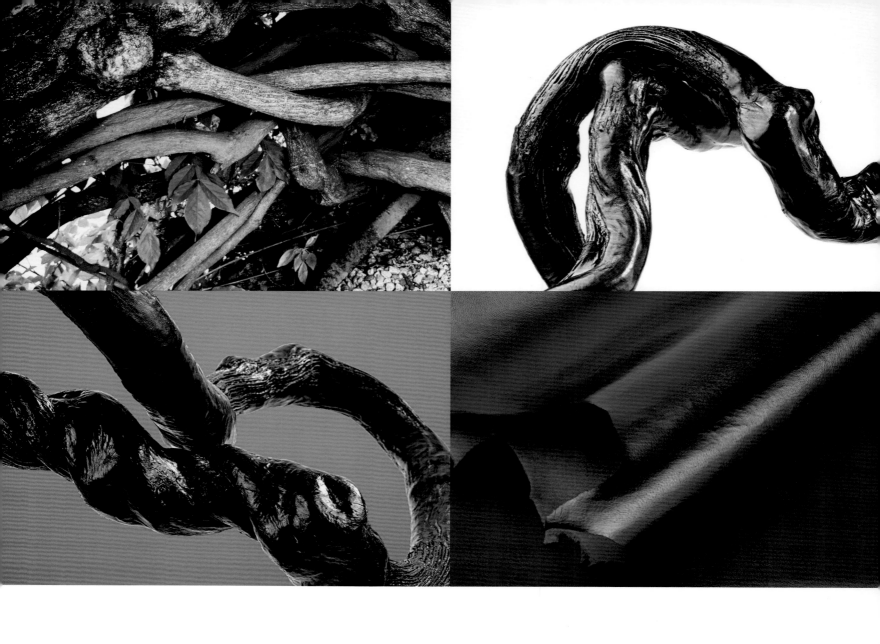

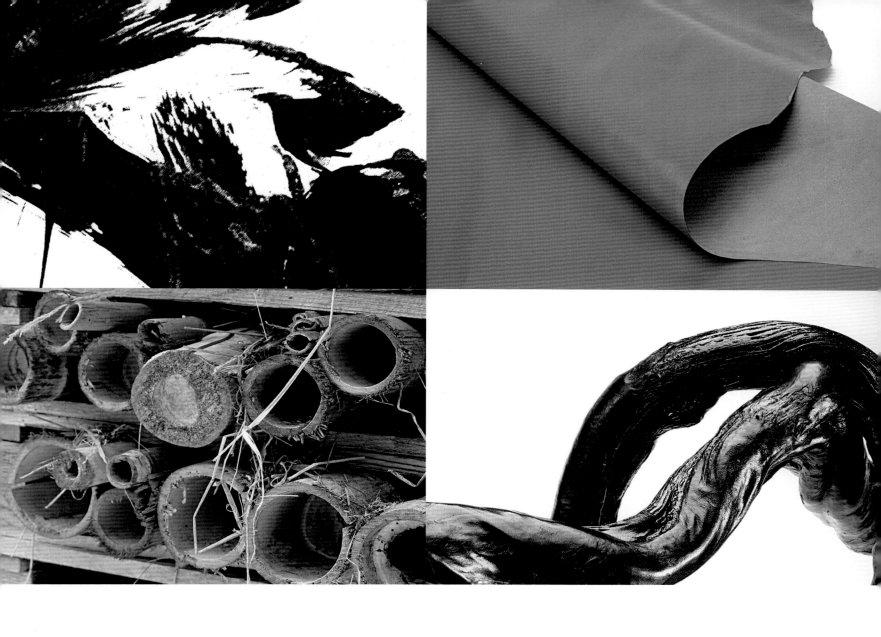

運用綜合美學的知識，把革工藝術語言重新
組構。將華人傳統「行草」美學的特點，用新
時代印記，反映於東方的精神中。

By applying the knowledge of aesthetics synthesis,
the language of leathercraft is restructured. With the
imprint of a new era, the aesthetics of the traditional
Chinese cursive writing are reflected in the spirit of
the East.

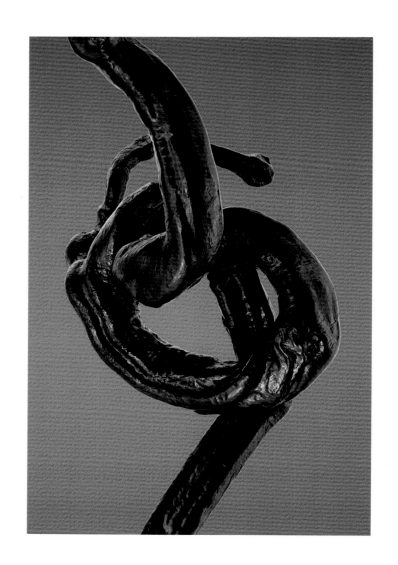

Cursive writing does not have a set form. Even though the beauty of the ink in motion seems unconstrained, it presents the beauty of metaphysical imagery.

「行草」的書寫，沒有一定的形式，墨韻的運力之美，看似天馬行空，卻呈現形而上的意象藝術之美。

墨運（二） Ink in Motion II
92cm x 15cm x 62cm
墨運（三） Ink in Motion III
102cm x 62cm x 33cm
墨運（四） Ink in Motion IV
115cm x 33cm x 70cm

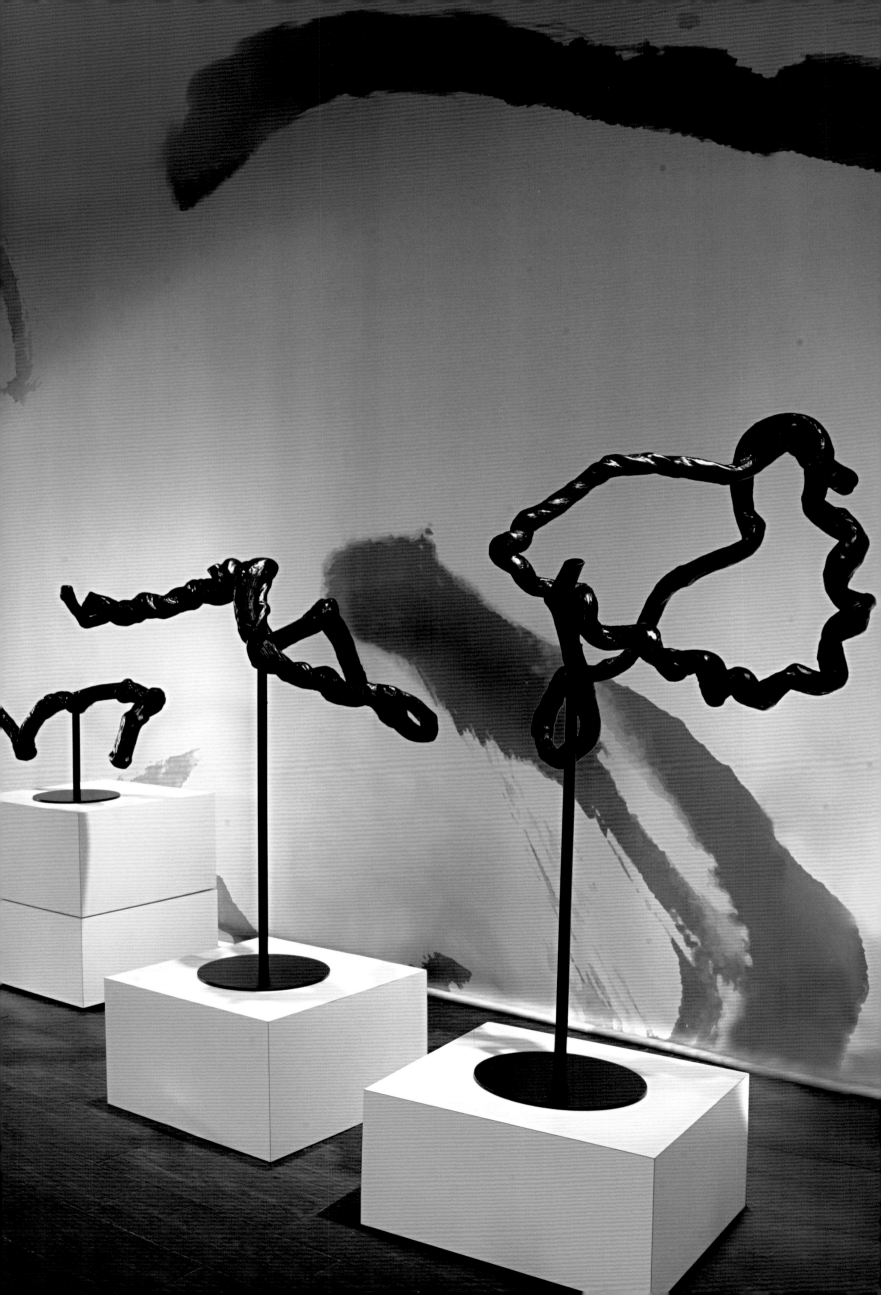

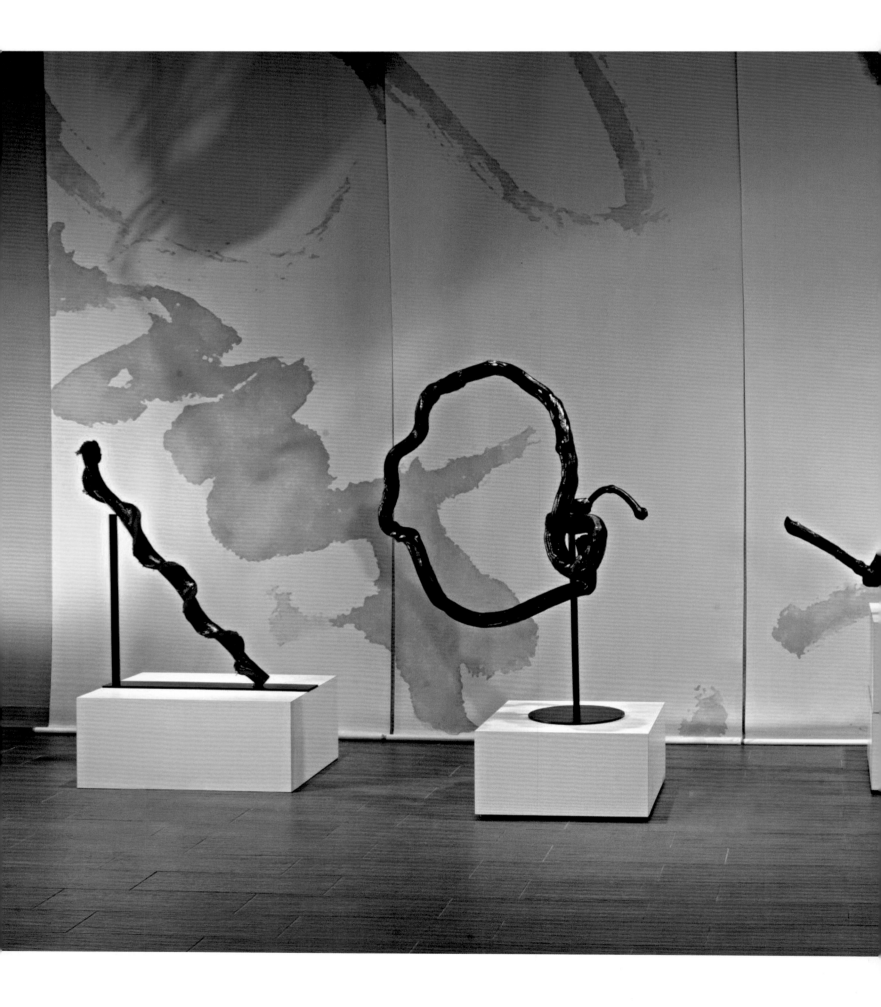

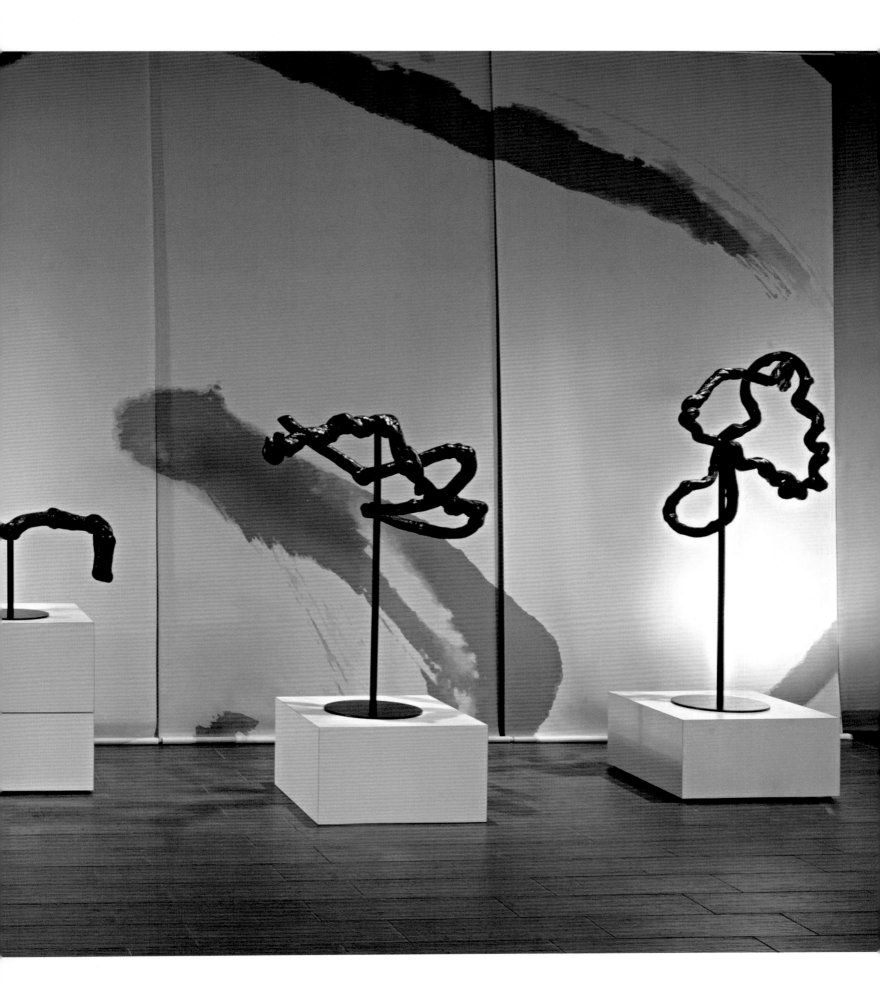

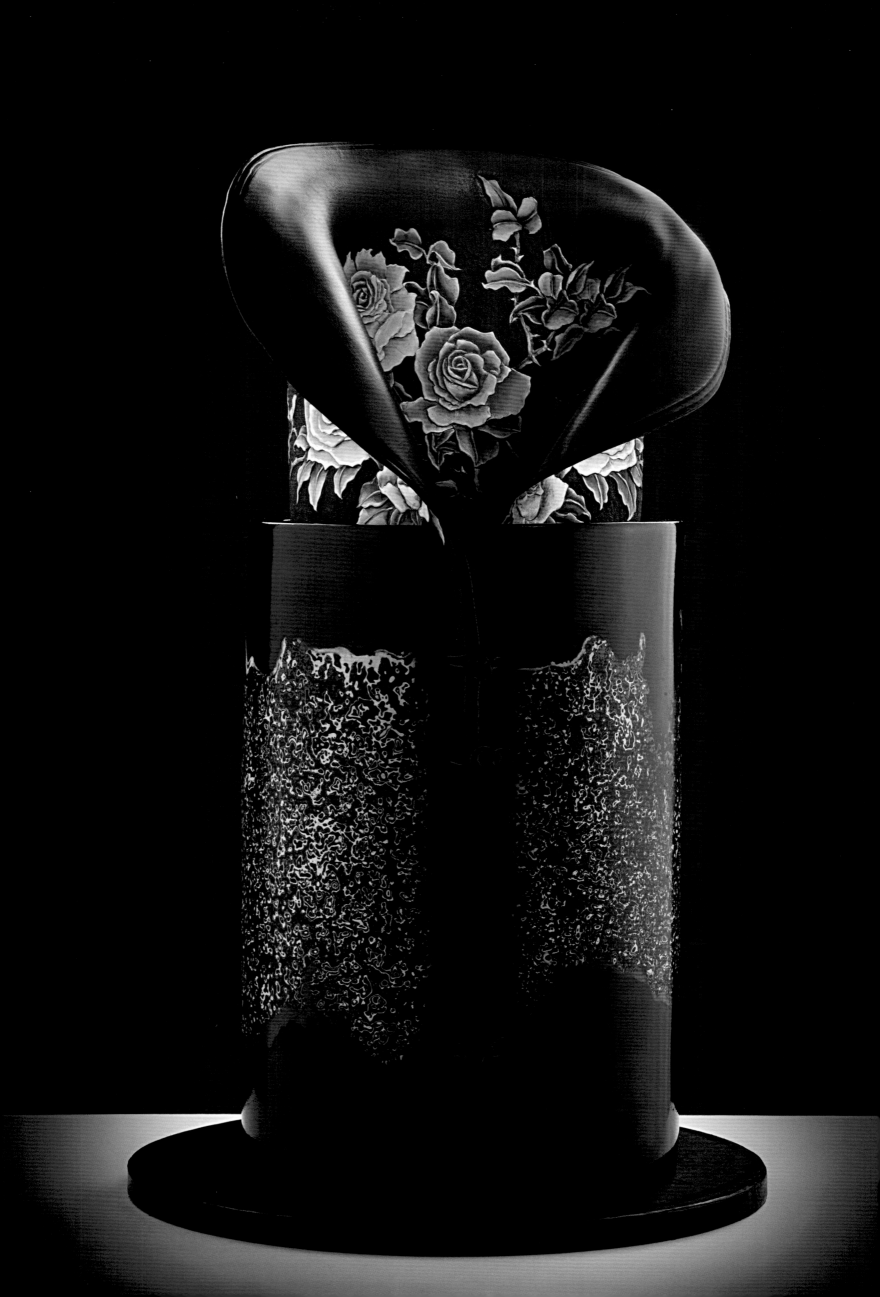

Rosa Elegancia[*]

"Rosa Elegancia" was inspired by the famous poem "Ode to the Goddess of the Luo River" in Chinese literature.

Cao Zhi, the author of the poem was a talented writer. His exquisite portrayal, interpretation, and metaphors of the beauty of the contemporary Chinese women of his time were the inspirations that have sparked creativity behind this piece.

The piece is presented in the form of a set; the two pieces can either be displayed together or separately. The techniques employed encompass the fields of lacquer and leathercraft, while soft and hard materials are pitted against one another, combined, and fused together. By incorporating the features of multiple elements, the abstract feminine characteristics depicted in literature are transformed from abstract texts into concrete expressions. Playing with the visual sensory experience thus allows more room for imagination…

* "Rosa elegancia" means "elegant rose" in Spanish. The original title in Chinese ("瑰姿艷逸，儀靜體閑") was taken from the "Ode to the Goddess of the Luo River." It can be roughly translated as "elegant and gorgeous, poised, and composed," where "瑰" has the double connotation of "rose" and "beautiful." This piece is also known as "Lady Zhen Decoration," which was the title adopted for the entry of A' Design Award & Competition.

瑰姿艷逸，儀靜體閑

「瑰姿艷逸，儀靜體閑」作品，創作靈感來自中國文學名賦中的「洛神賦」。名賦作者曹植文彩斐然，對當代華人女性美的精妙刻畫，詮釋和譬喻，激發了創作者的創意思維。

作品以套件的方式，具分合雙用的特色呈現。漆藝與革藝的跨域工法，材質軟硬反差後的複合與融合；將文學中抽象蘊諭的女性特質，藉由多重元素的特性，從抽象文字的描繪，做具象的表達；經視覺的感官激盪後，增添更多的想像空間…

瑰姿艷逸，儀靜體閑
Rosa Elegancia
23cm dia. x 50cm

The writer Cao Zhi had fictionalized his yearning and love for the Goddess of the Luo River after they met. His prose is filled with soft and rich imaginations, interpretations, and metaphors, which includes exquisite and detailed descriptions of the beauty of Consort Fu's appearance, clothing, polished manner, and refined words. For the literati of the time, the Ode became a source of spiritual sustenance for their feelings and passions for the women they admired...

文學家－曹植，虛構了自己與洛神邂逅相遇的思慕與愛戀。

柔美豐富的想像詮釋與譬喻。辭采華美細膩的描述宓妃的容儀服飾之美，以及識禮儀，善言辭的氣質。

為當代文人筆下，對心儀的女性的情思繾綣，若有寄託⋯

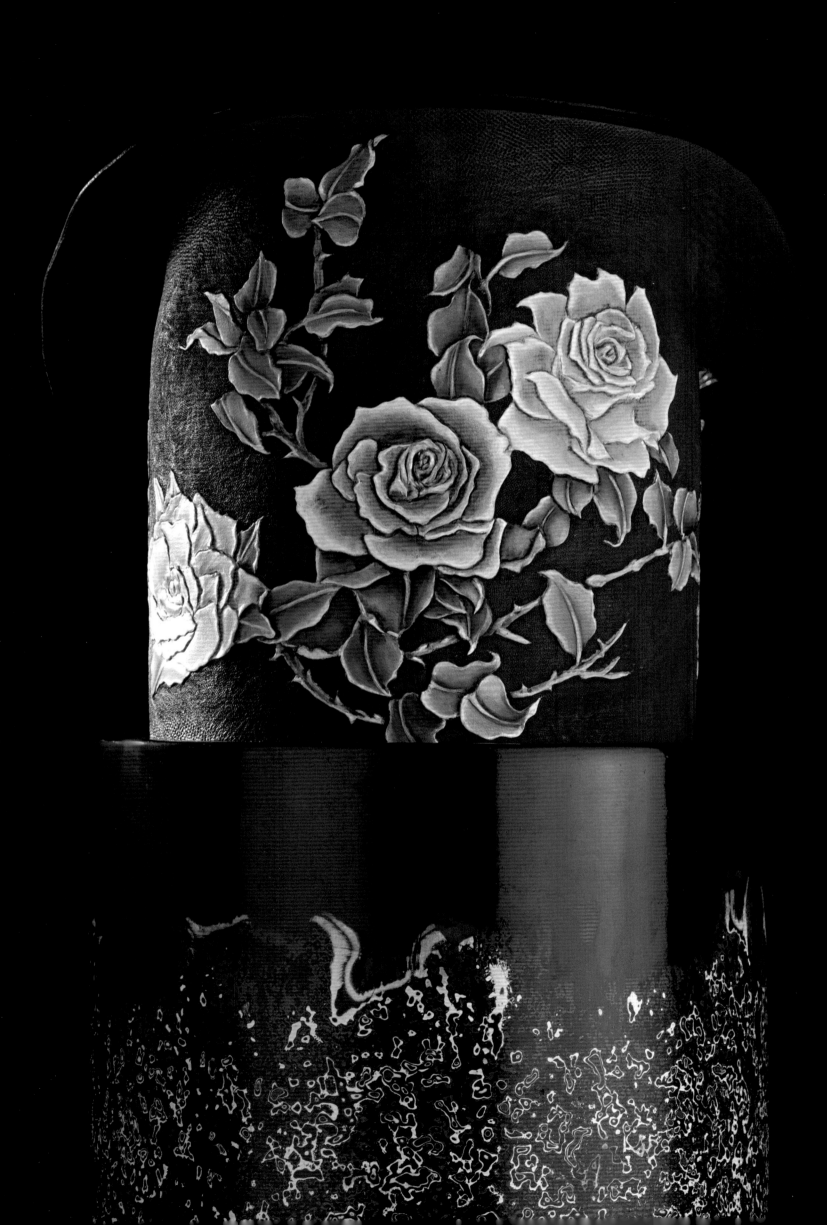

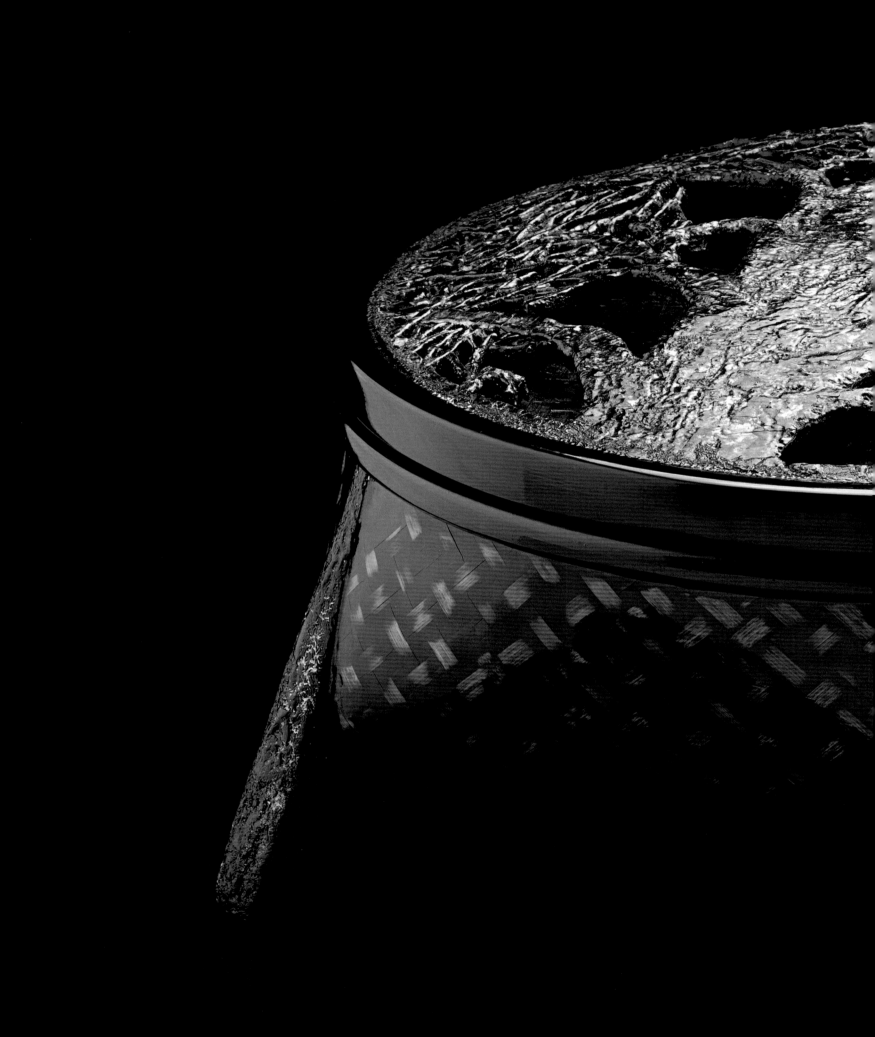

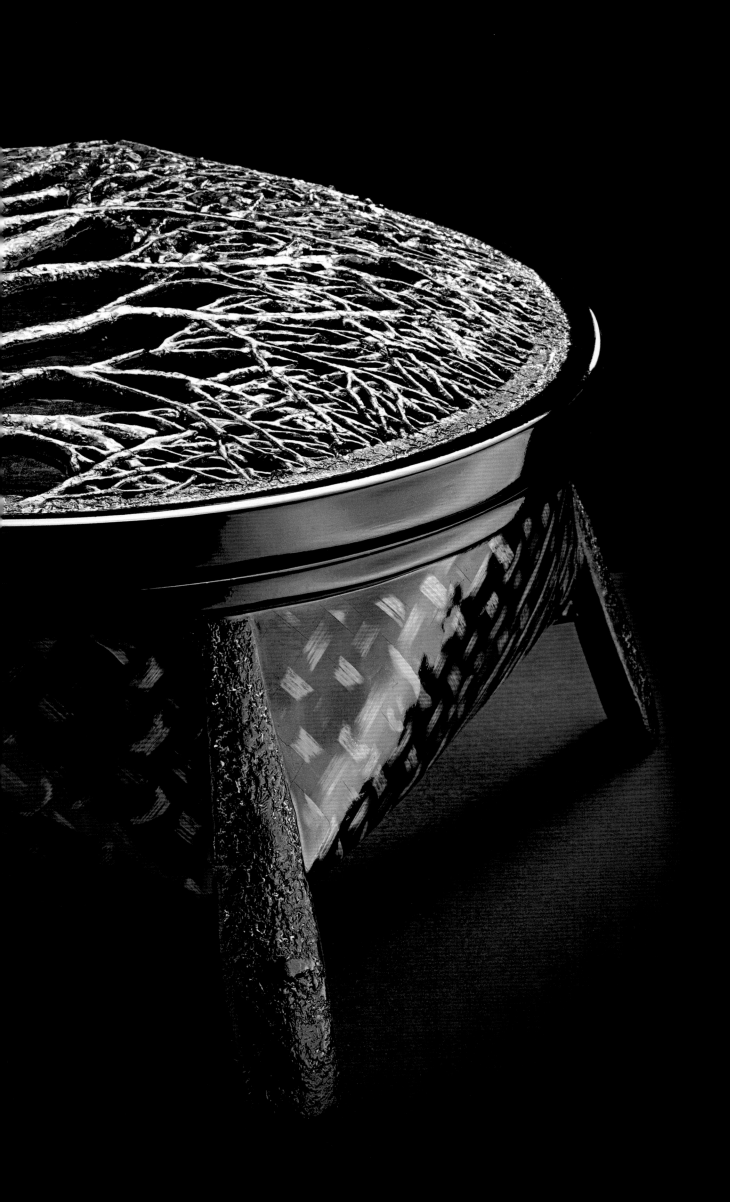

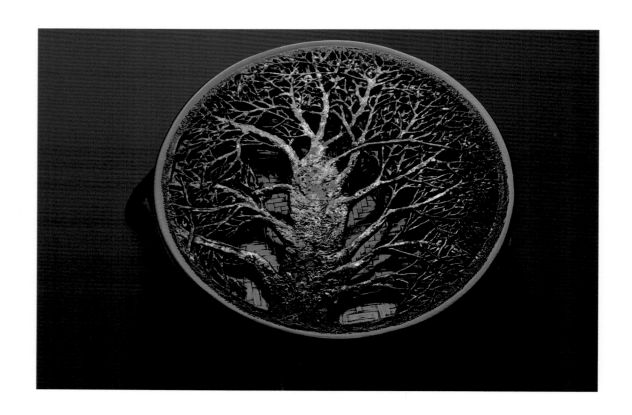

Waiting

Baring the body, it does not know whether it feels sad or happy; in the season that is soon to be gone, it gently strokes away the surrounding cold; taking the air as nourishment, it awaits the warm and blooming spring.

盼

它裸露著身體，不知道是悲傷還是歡樂；在即將離去的季節，把四周的冷輕輕撫去；以空氣為養份，等待春暖花開的日子。

盼 Waiting
40cm x 37cm x 110cm

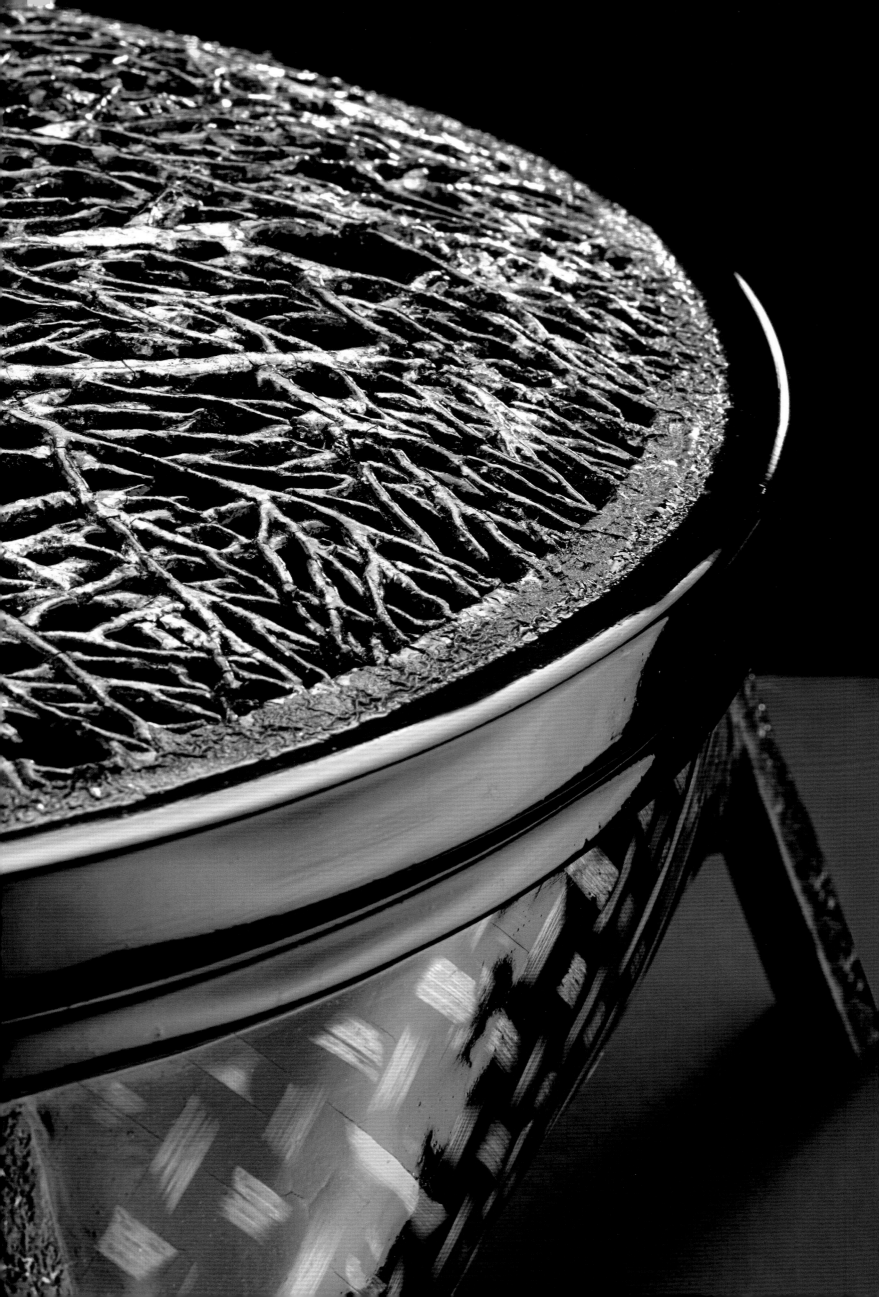

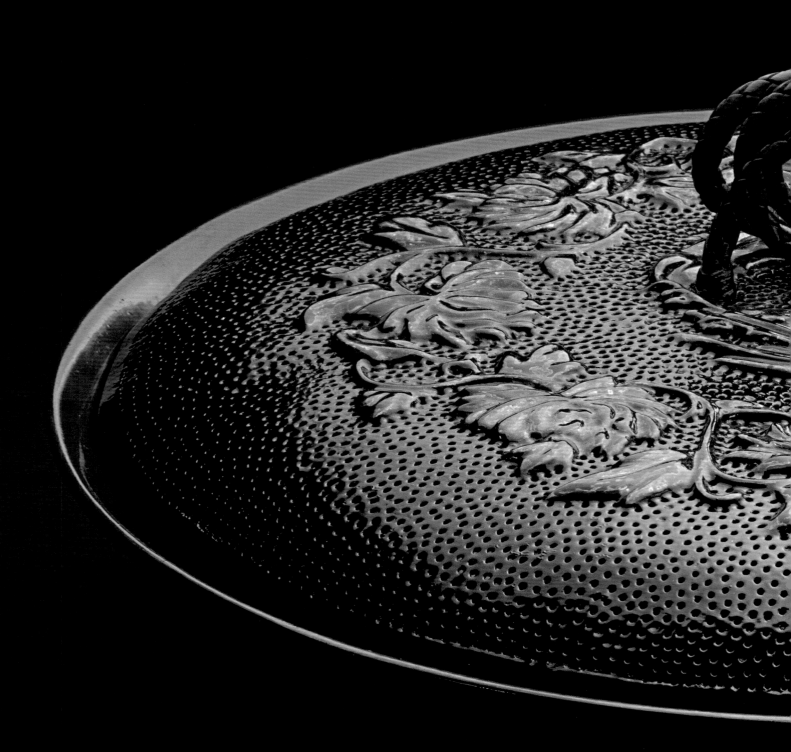

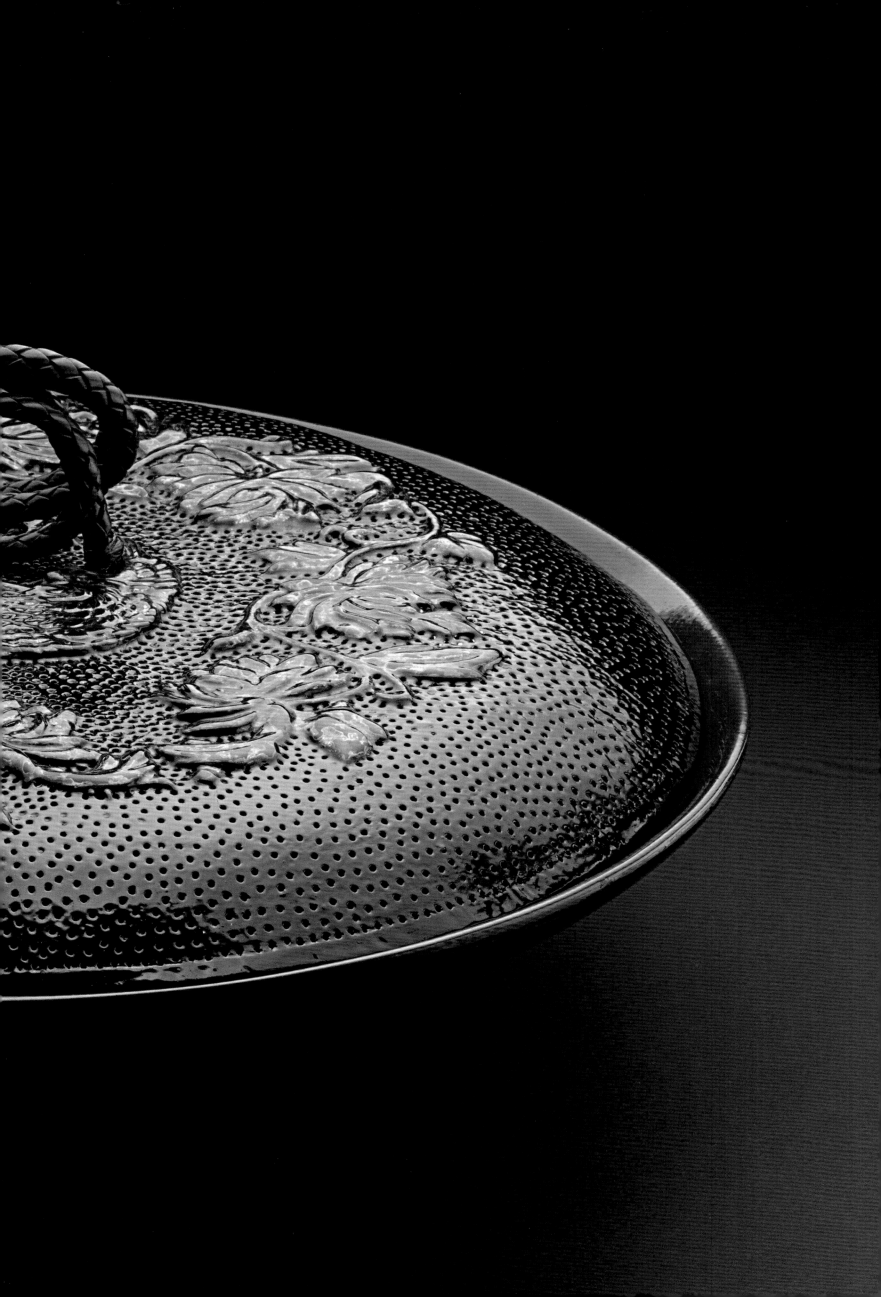

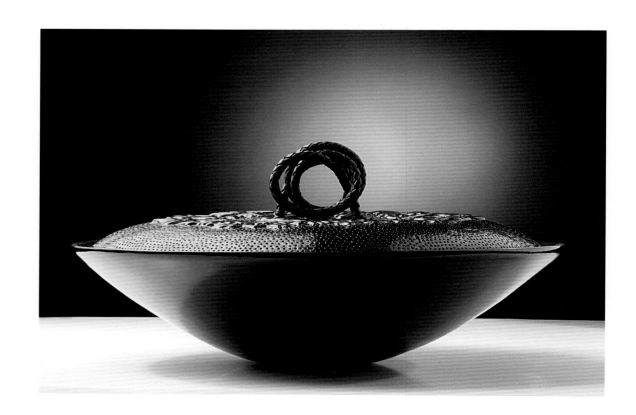

Bliss & Harmony

Chrysanthemum represents "bliss",* and the round shape symbolizes "harmony." All is well when harmony is upheld.

* Chrysanthemum (菊) is a partial homophone of"吉" (bliss, fortune) in Chinese.

吉合

以菊示「吉」，以圓爲「合」。
萬事吉旺，以和（合）爲貴。

吉合 Bliss & Harmony
46cm dia. x 20cm

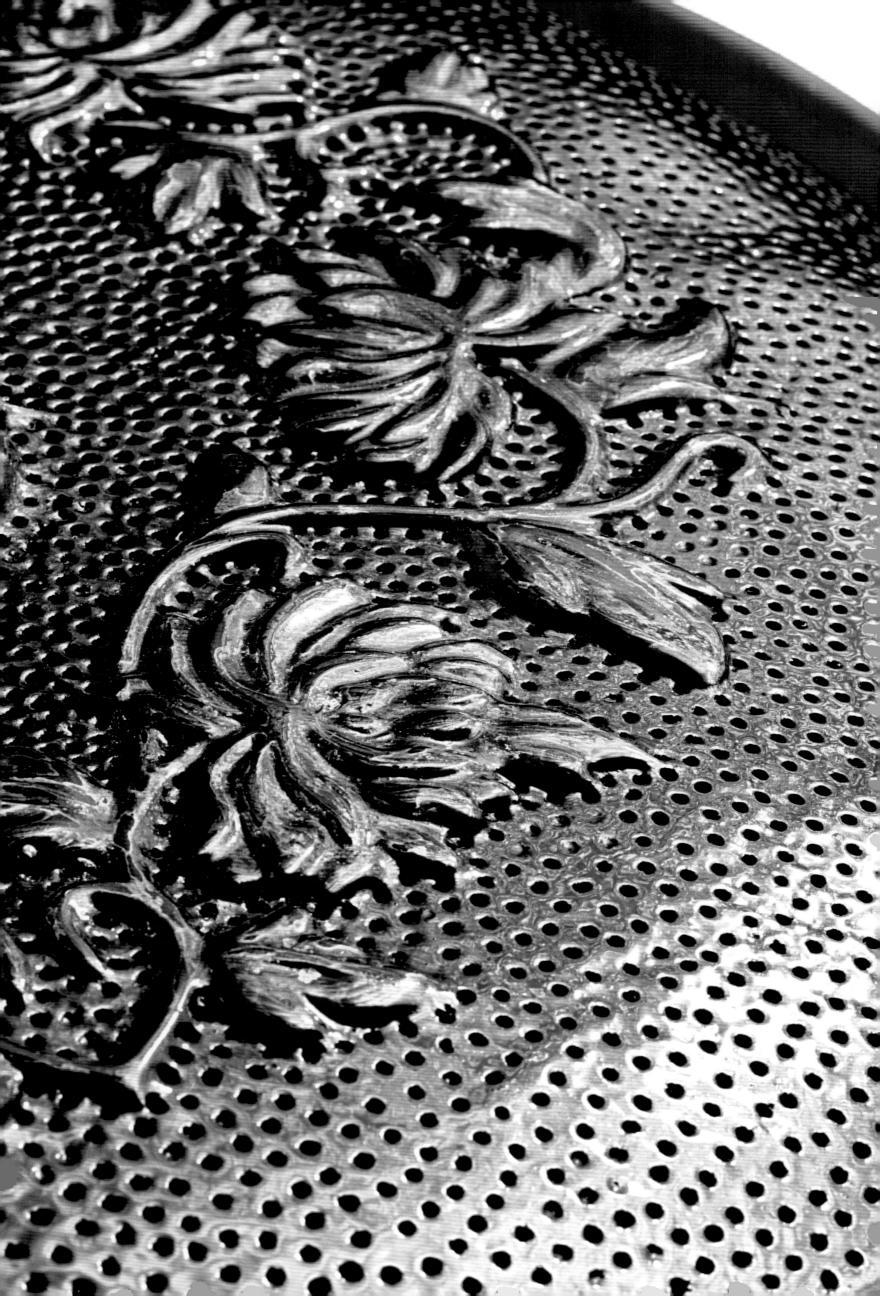

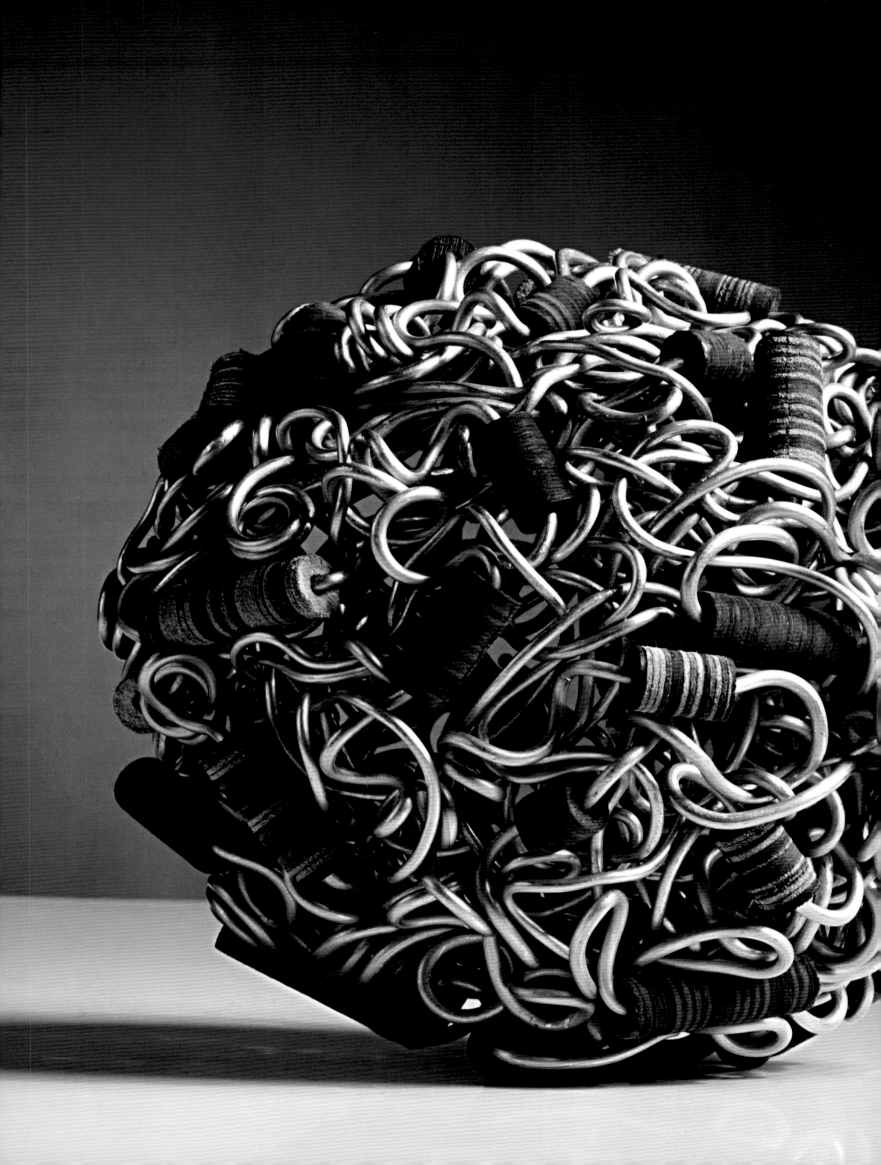

群動

感應大地強烈運動的變化，是生物的一種本能。包裹在網路世代中的人們，此類本能，是否被掩蓋而不具敏感。藉「群動」創作主題，反映當代議題。

平凡之中，反映了生活的事實。

此起彼落無常後的群動，令人目眩。平安成爲其中最大的祝福…

Collective Sensing

Sensing changes in the strong movements of the earth is a biological instinct. For the people who are enveloped in the internet generation, has such instinct been obscured? This is the contemporary issue that is reflected in the "Collective Sensing" series.

The ordinary reflects the facts of life. One after the other, the collective movements following an upheaval are dazzling. Safety and well-being has become the greatest blessing amidst them all…

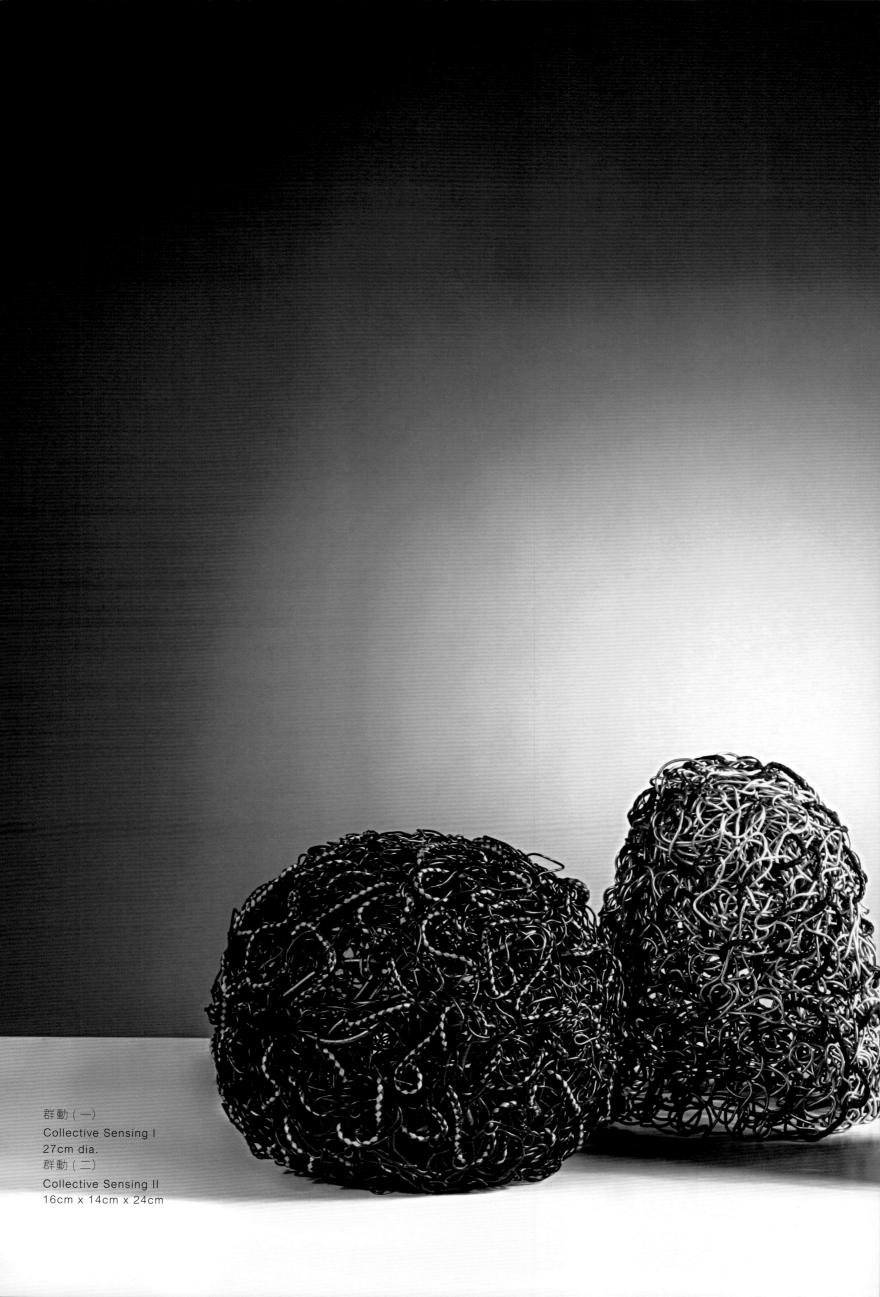

群動（一）
Collective Sensing I
27cm dia.
群動（二）
Collective Sensing II
16cm x 14cm x 24cm

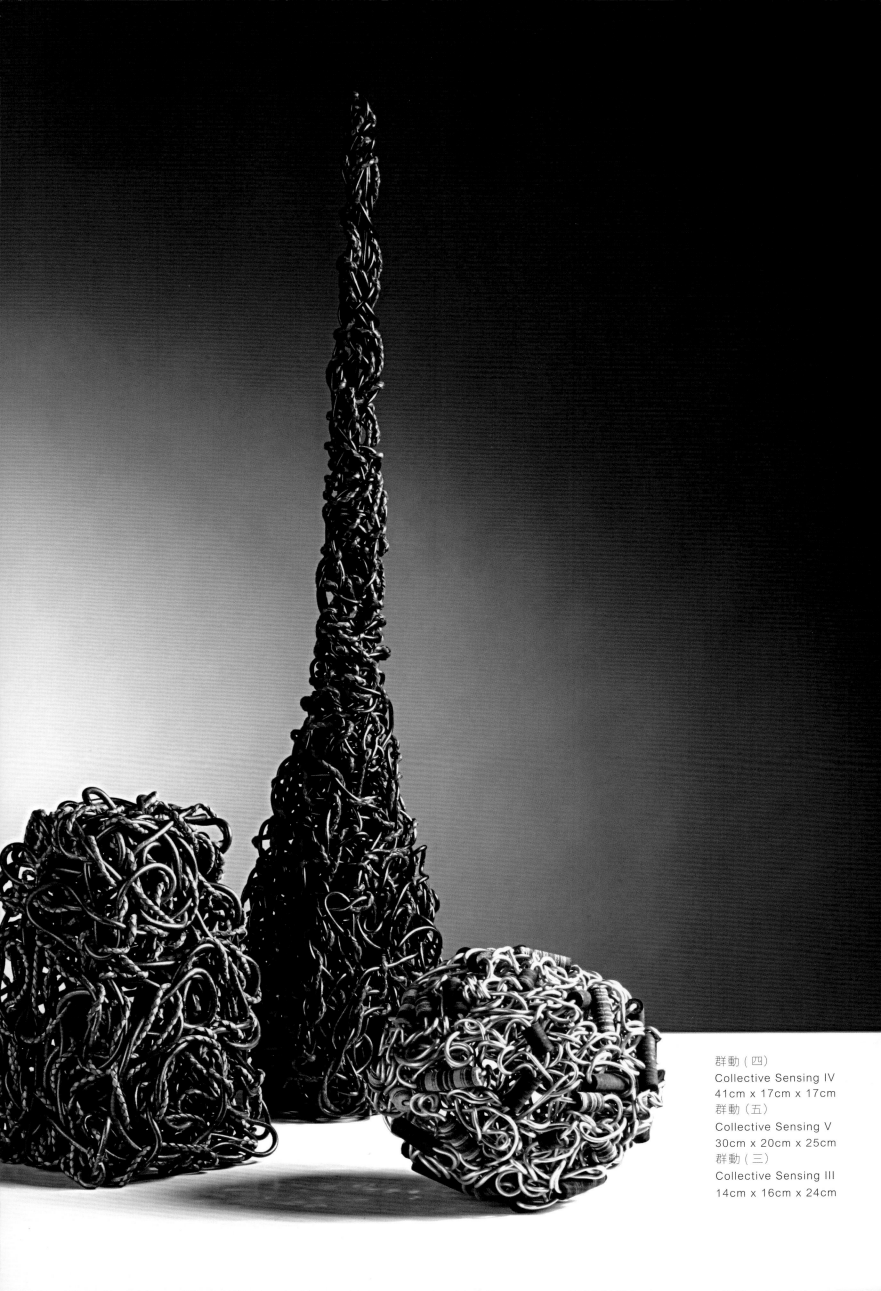

群動（四）
Collective Sensing IV
41cm x 17cm x 17cm
群動（五）
Collective Sensing V
30cm x 20cm x 25cm
群動（三）
Collective Sensing III
14cm x 16cm x 24cm

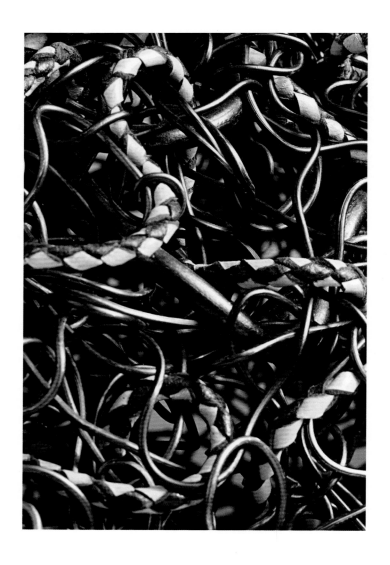

Humans are social animals. In the struggle against nature, the power of humans will only show when they bind together as a whole. When the earth moves or changes dramatically, the sensing ability of the human body is even more precious because humans can communicate through language. People can provide details on their precursory perceptions for others to record, or to dwell deeper into the physiological signals, premonitions, and possible coping measures.

人，是社會的動物，即使在同自然界的鬥爭中，人也只是作為一個整體，才能顯示出他們的力量。

大地巨烈運動或變化，人體的感應在生物感應中，更顯彌足珍貴。主要源於人們可以藉語言溝通，告知更多前兆感應的細節，提供人們進行記錄或探索更多物理訊號，及大地變化前兆的訊息特徵，與可能對應的自處方式。

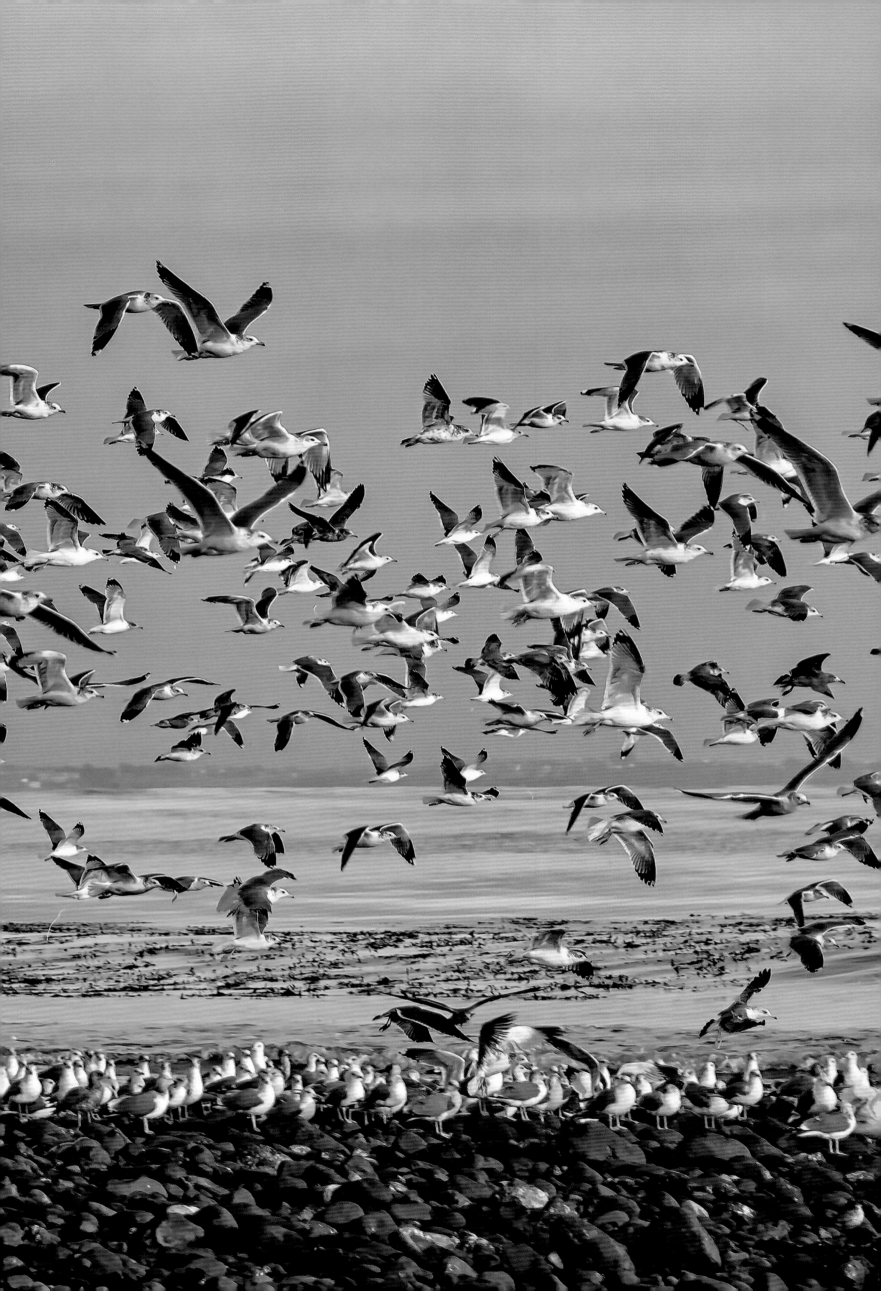

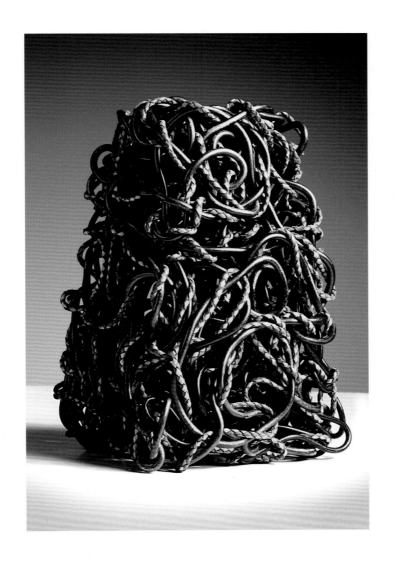

Flocks of birds are flying. Are they migrating, or are they in transit? Is it the end of spring, or the coming of fall? Perhaps it could also be the latent or overt premonition of the shocking event that is about to take place.

群鳥飛舞，是遷徙、是過境？是春去或秋來？亦或隱含著即將發生，或隱或顯的震撼前兆。

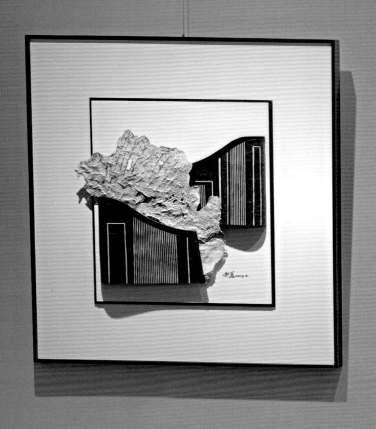
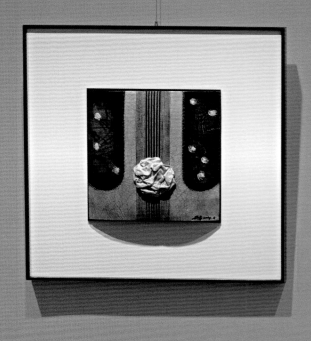

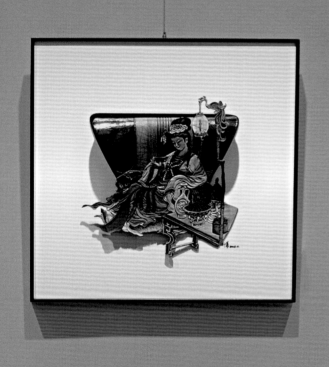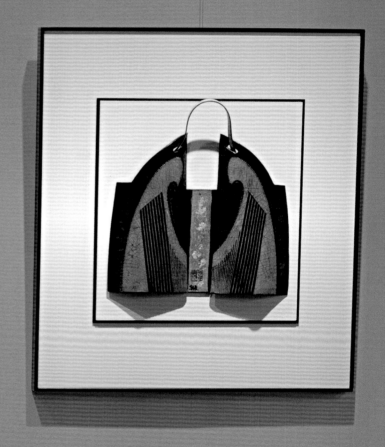

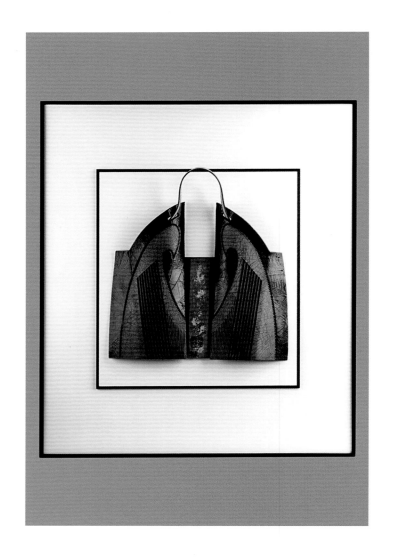

Lute: Half Covered

After being transformed by various parameters (height, frequency, and dose of the source sound), sounds are expressed visually through direct interaction.

半掩琵琶

聲音，通過各樣的參量（高度、頻率、聲源劑量）變形後，以最直接的交互作用，表現在圖象之中。

半掩琵琶 Lute: Half Covered
64cm x 55cm

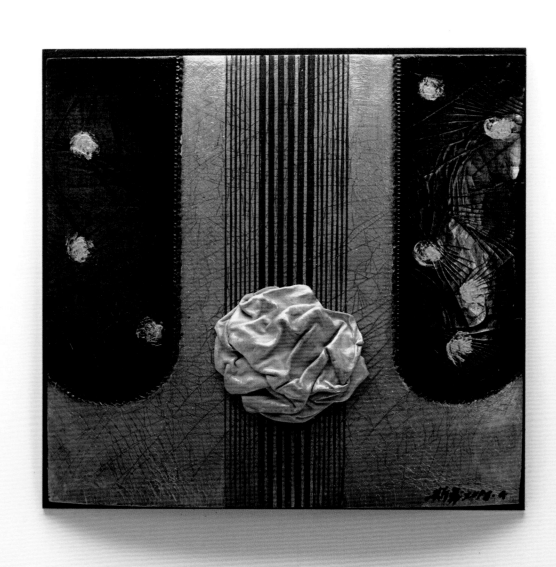

Breaking Free

Peeking into the wall makes one narrow-mind. On the other hand, one becomes dazzled and fascinated while facing reality. Being dazzled is a beautified state resulting from the rupture of one's own experience; open-mindedness has become an attitude when one is able to confront the reality.

牆裡牆外

窺視牆內，似管窺天；面對現實，目眩神迷。目眩是一種美化後的形態，透過自身經驗的斷裂；「豁達」，成爲眞實可面對的一種態度。

牆裡牆外 Breaking Free
57.5cm x 53cm

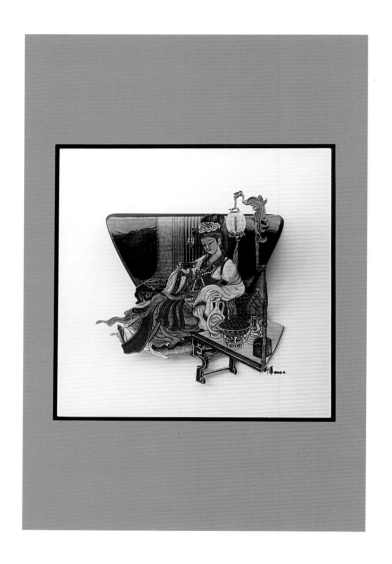

Now & Then

The classical text is visually integrated with the contemporary. With simple elements, it presents a modest and free-spirited perception.

今昔

古典文本與當代的視覺結合。以簡單的元素，呈現簡約而寫意的感知。

今昔 Now & Then
46cm x 45cm

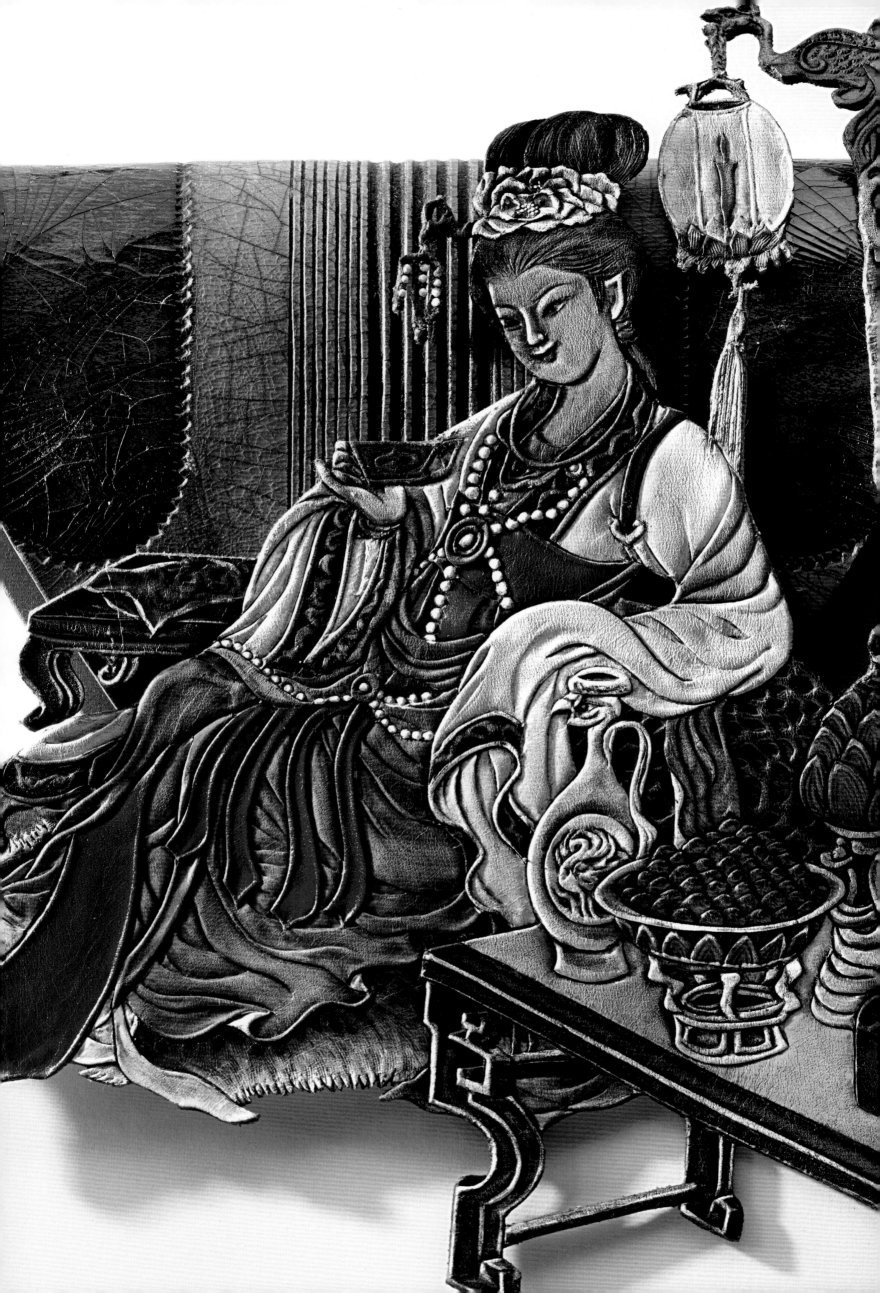

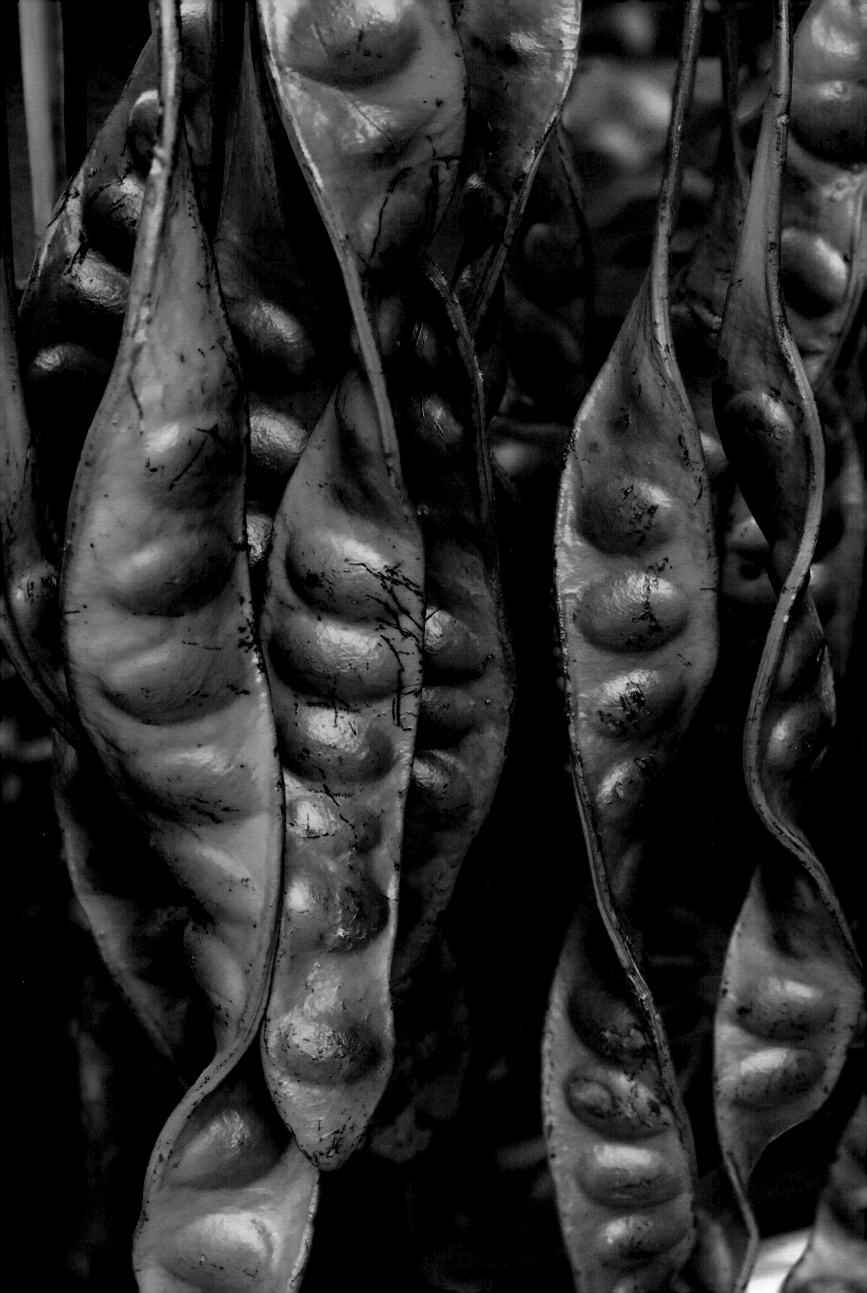

原聲曲線

創意始終來自生活。「食用」是否可以與「實用」連結？在熱情的非洲鼓樂中，節奏，連接了創作者在打擊樂聲中，多層次的想望，進而開啟了創意的敏感神經。

節奏是否可被看見？激發了創意深沈的思考…原聲曲線因而孕育而生，成為「紋革創生」中的另類新價值。

Primal Sound Curves

After all, creativity comes from life. Could "edible" be connected with "useful"? Amidst the passionate African drum music, the rhythm made a connection with the artist's multi-layered desire and turned on her radar of creativity.

Could the rhythm be seen? This question inspired creative thinking on a deeper level…as a result, "Primal Sound Curves" was born, which became an alternative new value in "Leather Art: Regeneration."

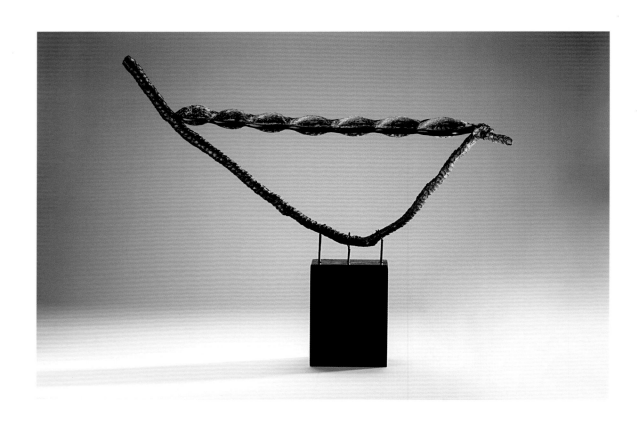

Equilibrium

平衡

When edible stink beans (also known as "petai" or "parkia beans") are instilled with infinite creativity and ideas of design, they are no longer beans.

After the stink beans were dried by the passage of time, their texture of life changed. The vibrations of the beans against the pods created a primal acoustic sound. The different beats of the acoustic sound formed a beautiful rhythm. With a modified life texture, the re-shaped or naturally twisted stink beans were integrated with leathercraft and lacquer art; they became the classic "primal sound curves" that could be seen and heard.

當可食用的臭豆（又名美麗球花豆，巴克豆）注入無限的創意與設計思維後；豆子不再只是豆子。在時間淬煉後的乾燥臭豆，改變了生命紋路的樣貌。豆與豆莢間的碰撞，發出原聲。原聲經由不同的節奏，形成美妙韻律。生命紋路改變後的臭豆，形塑或自然扭曲，與皮藝、漆藝融合；成爲看與聽得到的，經典「原聲曲線」。

原聲曲線 - 平衡
Primal Sound Curves - Equilibrium
70cm x 11cm x 47cm

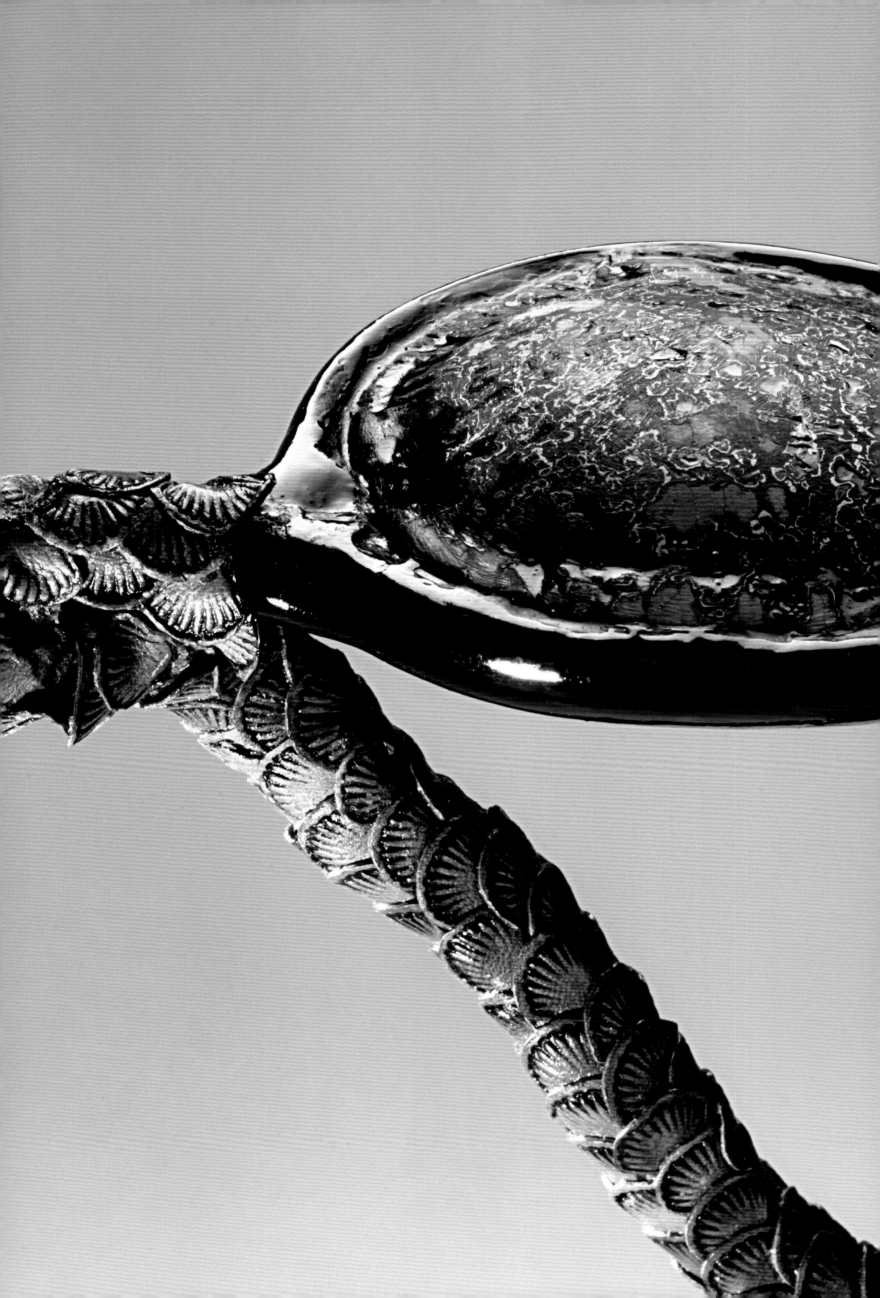

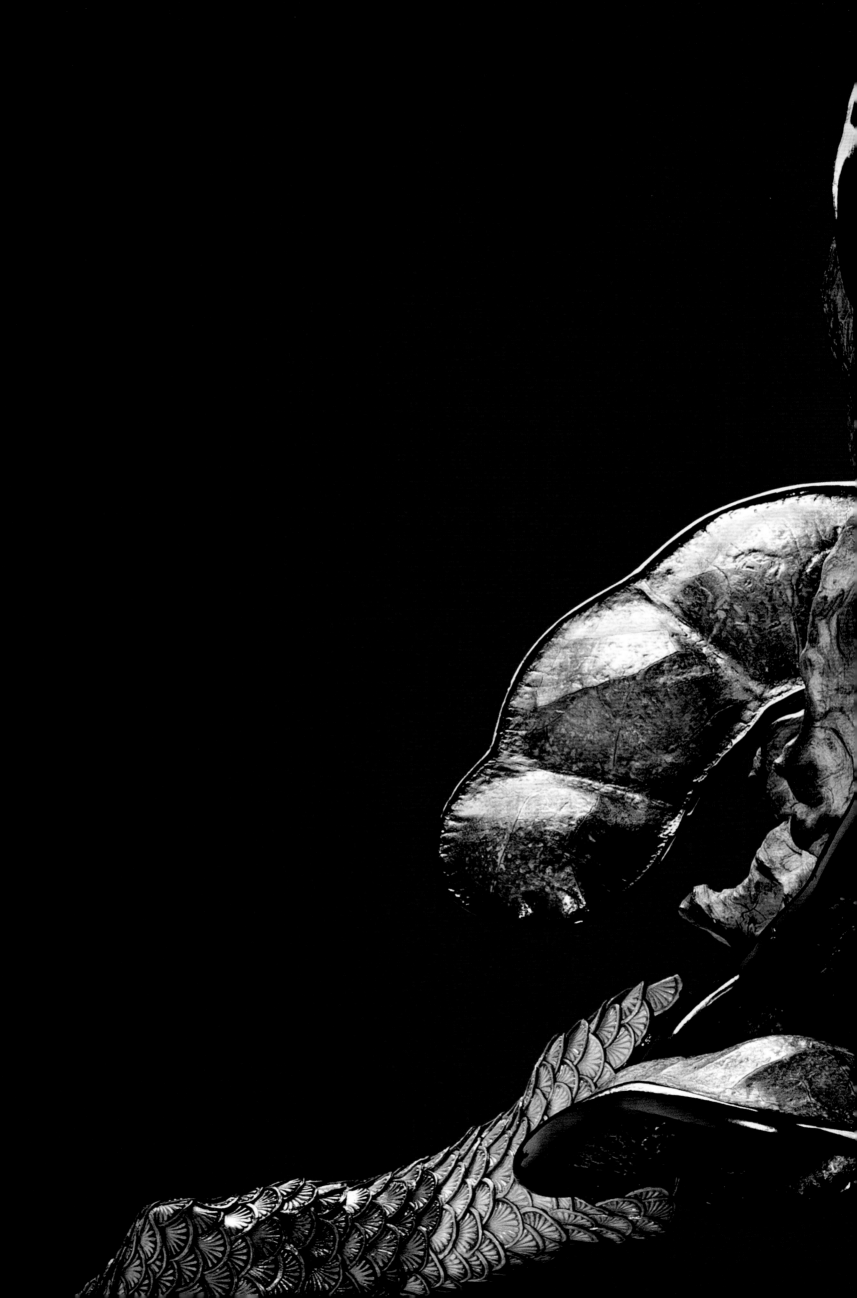

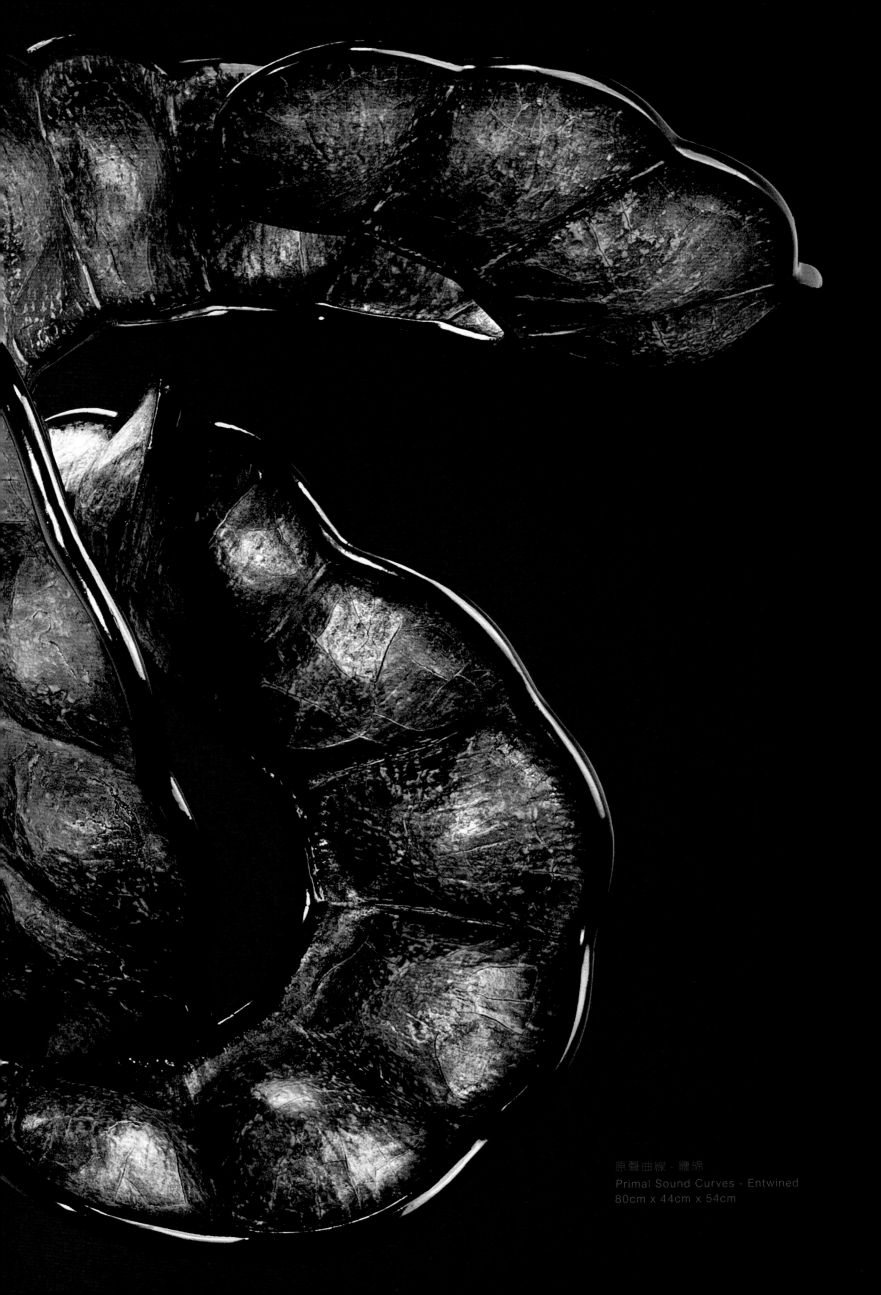

原聲曲線 - 纏綿
Primal Sound Curves - Entwined
80cm x 44cm x 54cm

Layers of lacquer and flowing textures were melded into the transformed curve, which then entered a dialogue with the rhythmic acoustic sounds created by resonance.

層疊的漆彩與流動肌理，融合於變身造型曲線中；並與共鳴後的節奏原聲，譜出了聲音的對話。

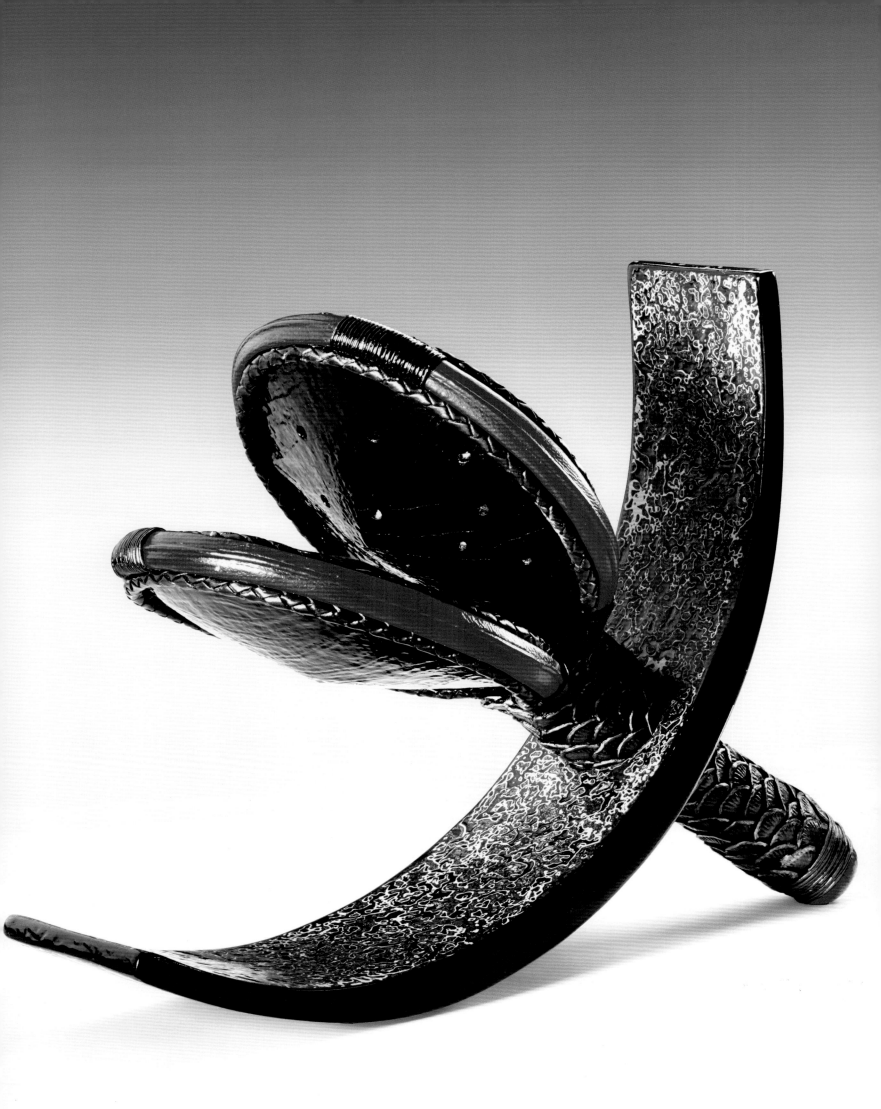

原聲曲線 - 對話
Primal Sound Curves - Whisper to each other
20cm x 8cm x 23cm

蒂・連結

連結是網絡的自然路徑，每一個節點的停留，
皆為創造美好的記憶。

STi's Web[*]

Connection is the natural pathway of the internet.
The stop at each node creates beautiful memories.

* "STi" is an abbreviation of "Szu Ti," the first name of the
artist.

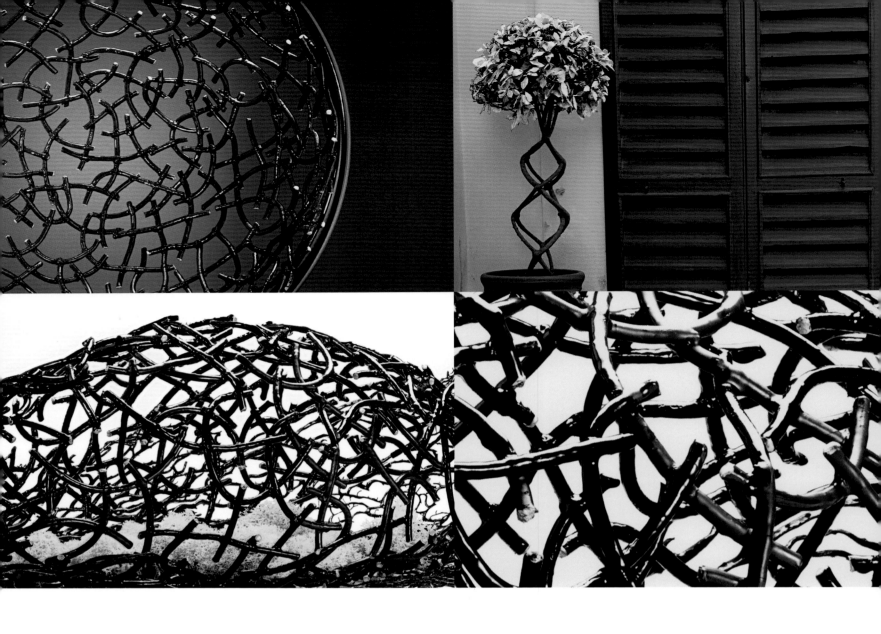

As the last character of the artist's name, "Ti" entails the concept of connection; it is the part where the branches and stems are connected. The radicals of the Chinese character "Ti" are transformed into a technical structure; building upon this, the connections of "Ti" are extended infinitely through the circular leather threads that represent the internet, thereby creating a dynamic art piece…

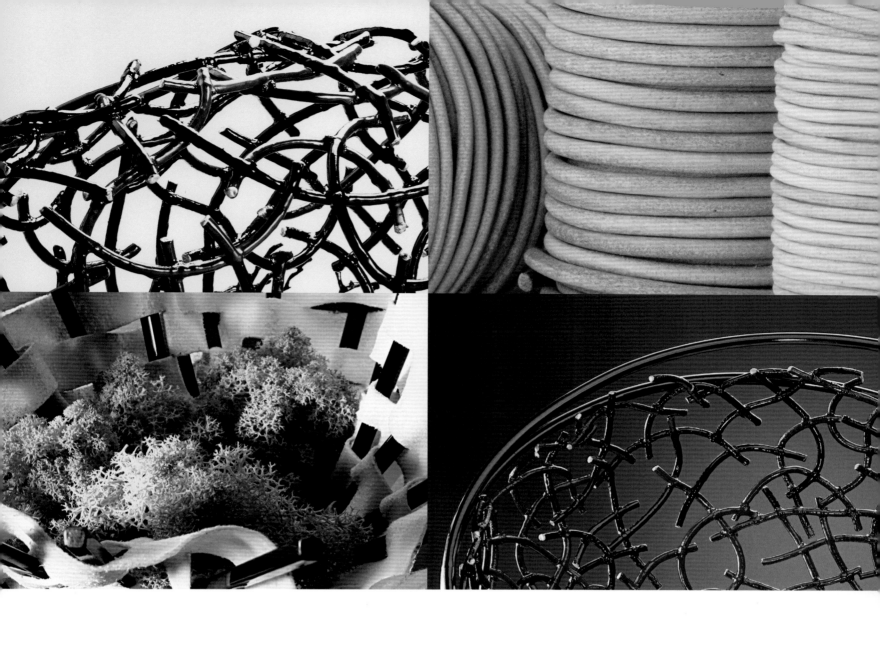

「蒂」是連結的概念。
枝莖相連的部分爲之「蒂」。

將文字本體「蒂」的部首「艹」，轉換成技法上結
構的呈現；並以此爲創作的基調，圓革線編織
的網絡思維，將「蒂」的連結，以無限延伸形式，
發展了多元的創作…

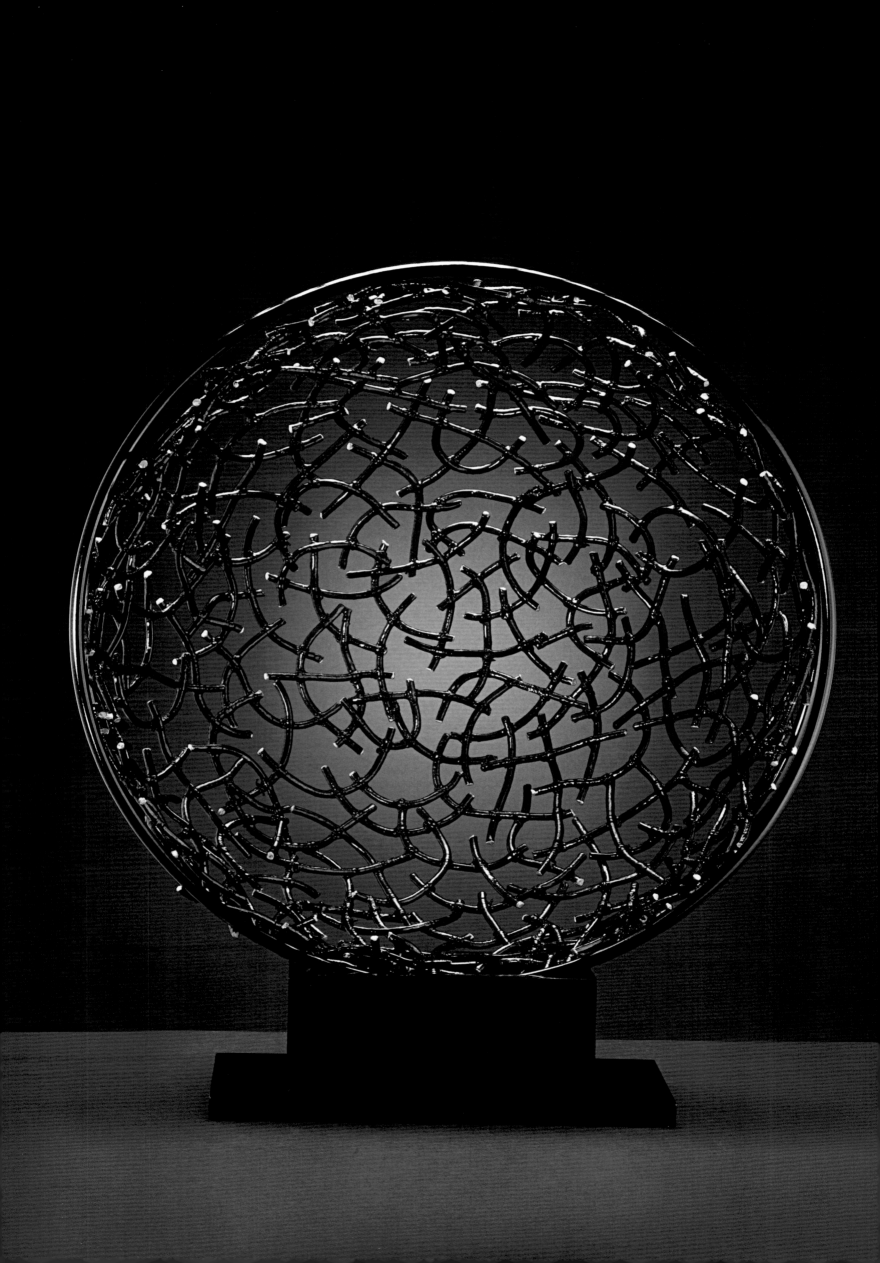

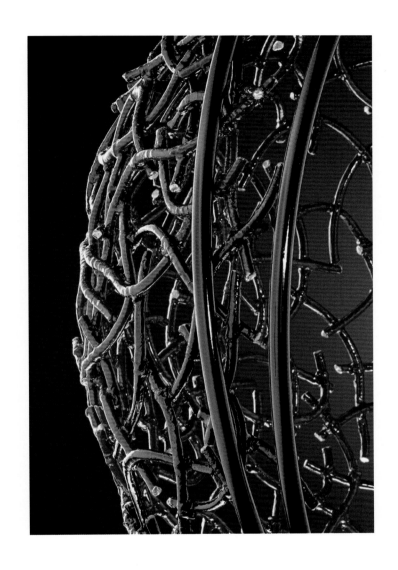

The connection of the global network has mobilized the pulse of the people. Implicit or explicit social relations, from accidental acquaintances to close relationships, are leading the fashions and trends of this ephemeral world.

全球網絡的串接，活絡了人們的脈動。或隱或顯的社會關係，從偶然的相識到緊密的結合，牽引著浮世繪中的潮流與趨勢。

蒂・連結 STi's Web
28cm x 59cm x 50cm

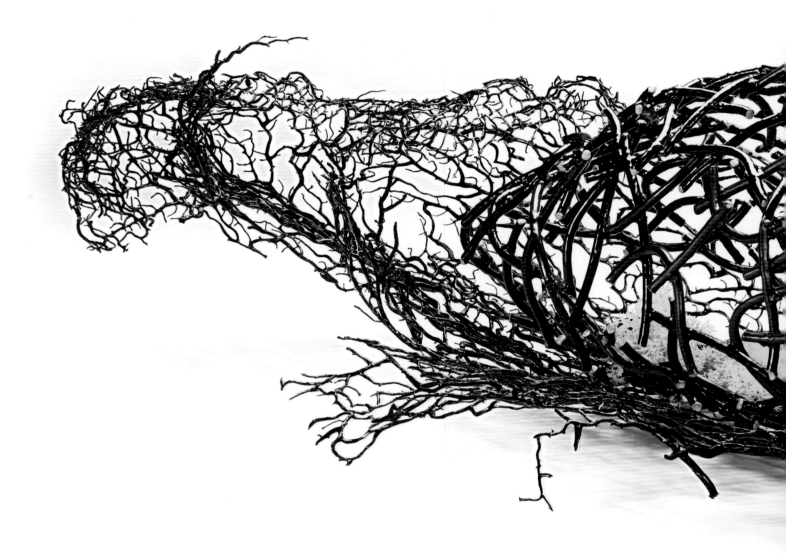

孕育

連結是網絡的自然路徑，每一個節點的停留，
皆爲創造美好的記憶。

Incubation

Connection is the natural pathway of the internet.
The stop at each node creates beautiful memories.

孕育 Incubation
70cm x 32cm x 30cm

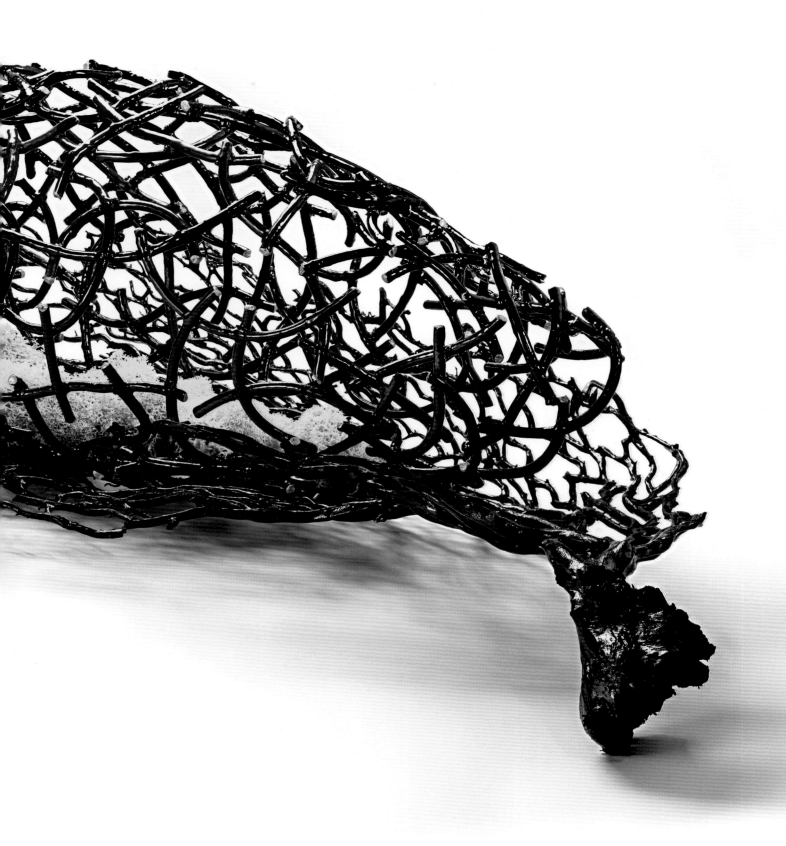

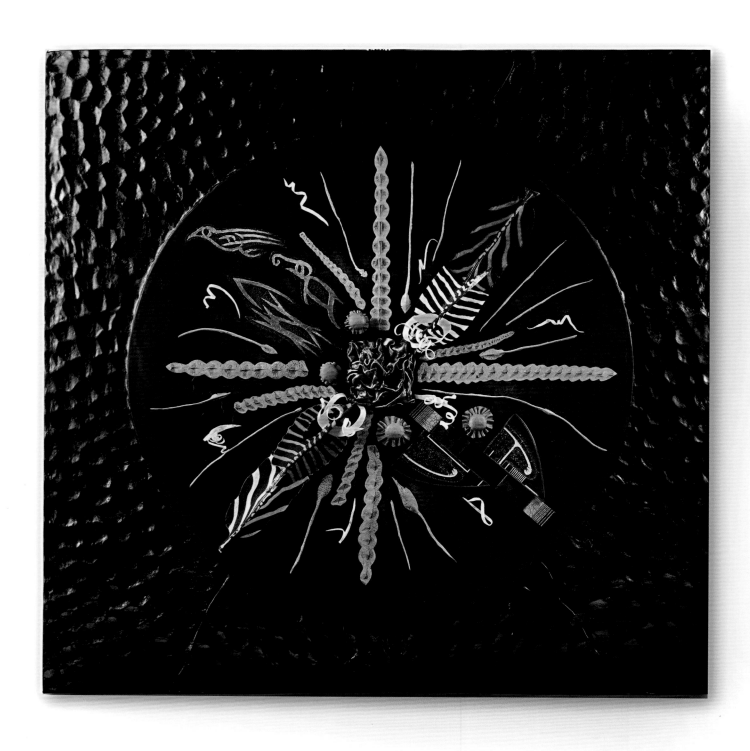

思緒　Thoughts
120cm x 120cm

思緒

生命帶來無限的希望，將生活的肌理，編織成流動的音符，思緒在其中飛揚，文字成爲美的註釋。

Thoughts

Life brings infinite hope, weaving the texture of life into flowing notes. Flying amidst the melody, words become the notes of beauty.

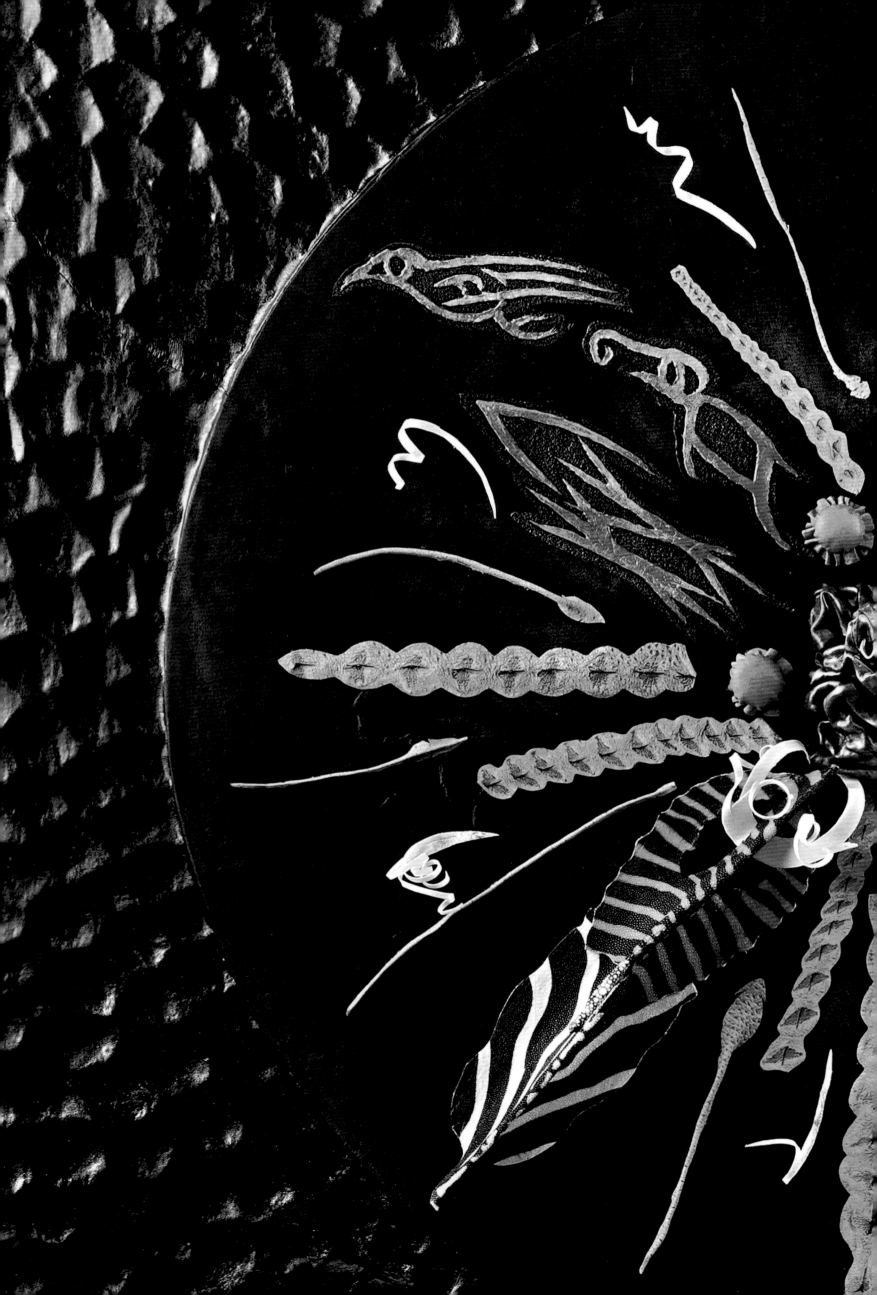

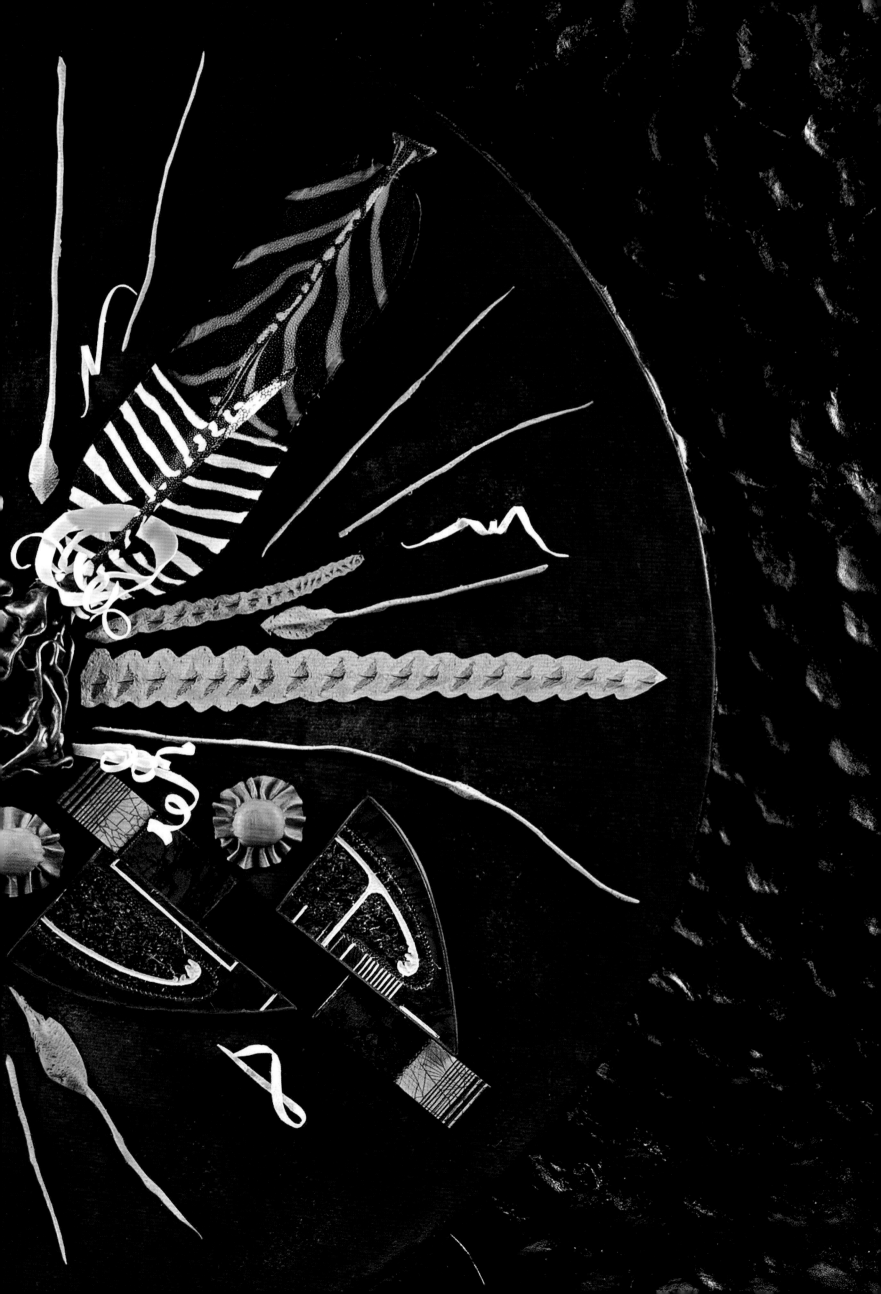

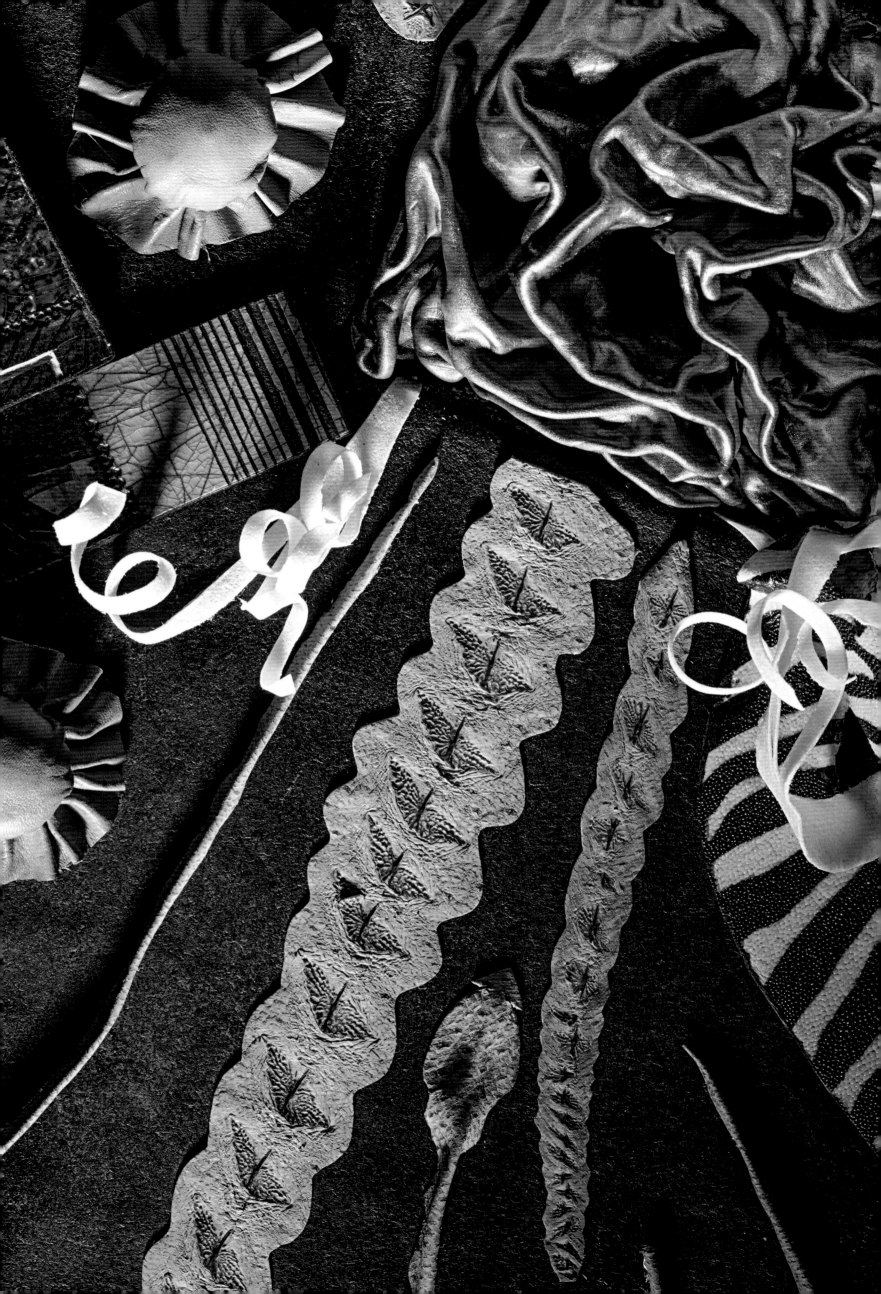

生存帶來動力，生命帶來希望。

繚繞的思緒，創作也許是最美的註釋。將感動
與懷想，用肌理和紋路來包裝。

Survival brings motivation, and life brings hope. For
the winding thoughts, art creations may be the most
beautiful interpretation, which allows us to express
sensations and nostalgia with textures and patterns.

記憶屬於自己歷程留下的痕跡，把依戀刻畫在紋理之中。

Record the traces left by one's own journey, and carve nostalgia into the texture.

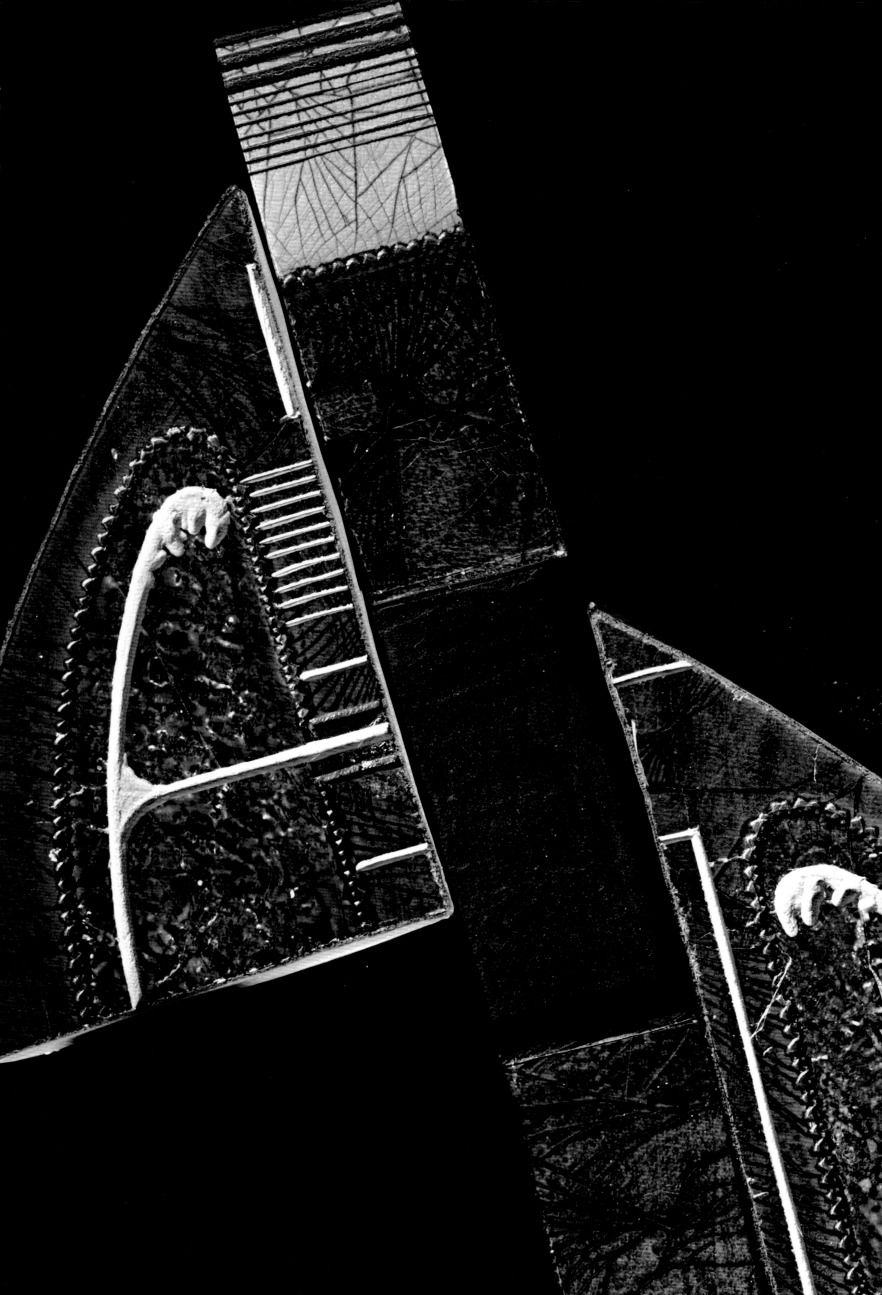

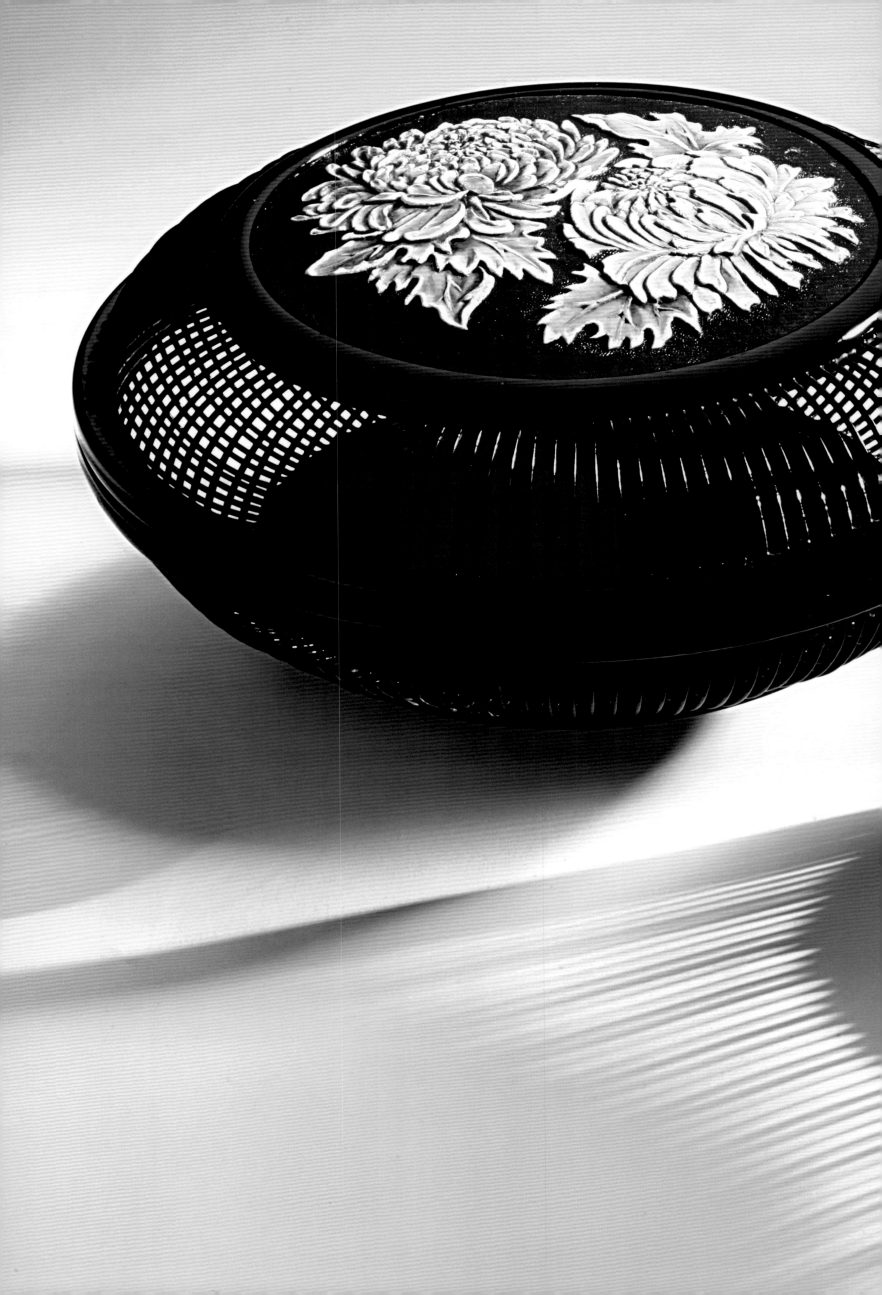

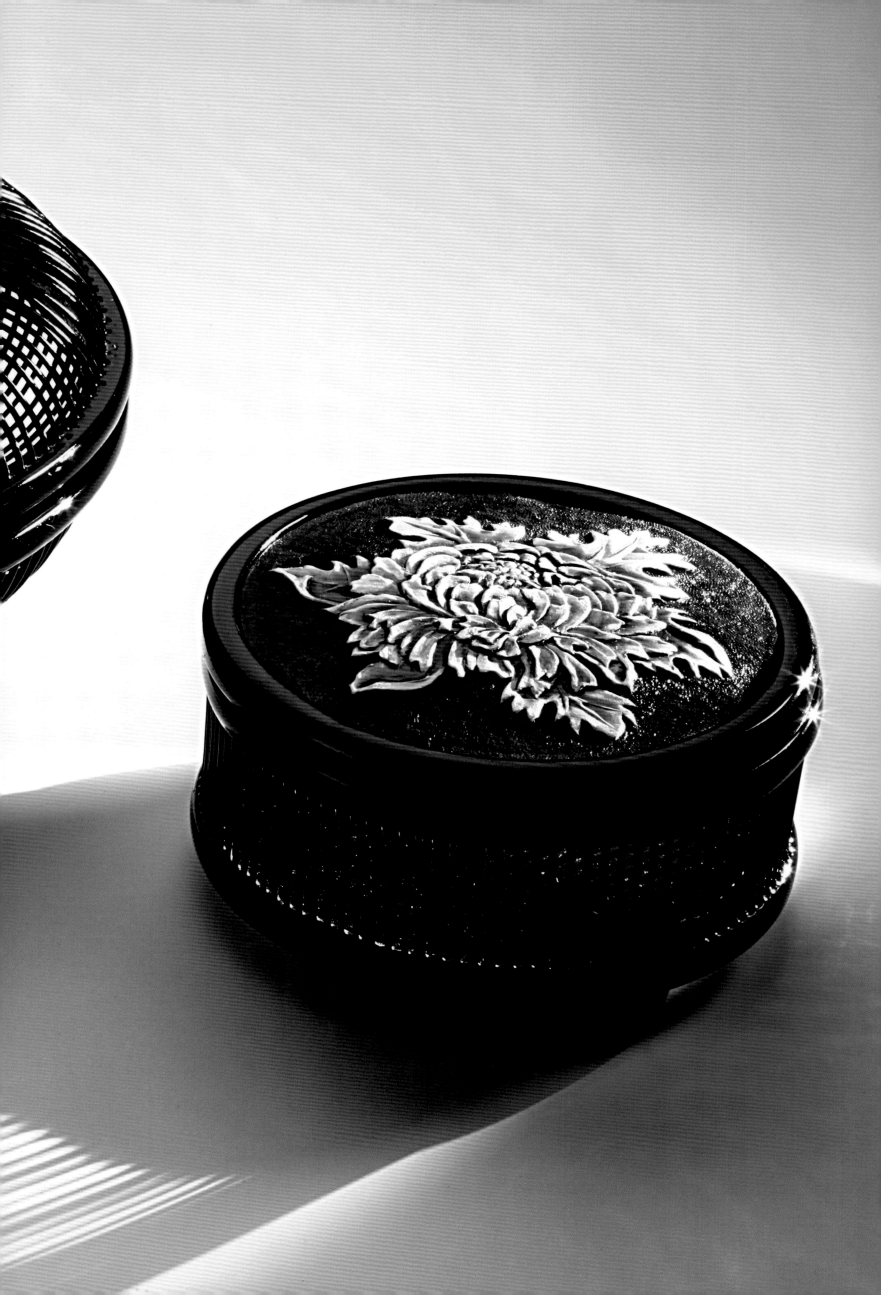

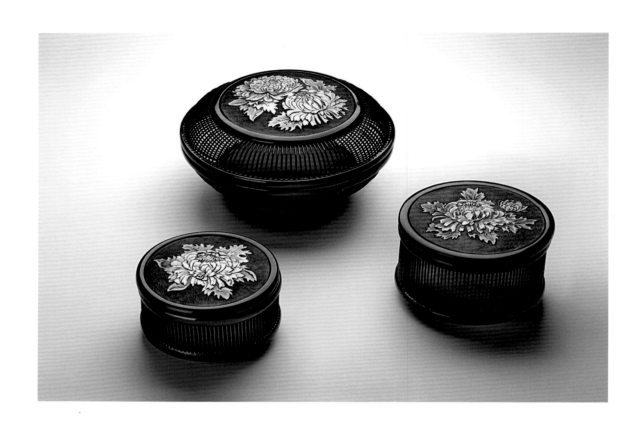

Elevating Prosperity

富貴疊升

Containable, extendible, and stackable, the bamboo boxes with patterns of prosperity carry generous widths and heights. Depending on the needs of the environment, they put on different appearances and sceneries.

可納、可伸、可疊的富貴紋樣竹盒，承載著有容的寬度與高度，因應環境所需，呈現不一樣的樣貌與風景。

富貴疊升（一）　Elevating Prosperity I
14cm dia. x 7cm
富貴疊升（二）　Elevating Prosperity II
16cm dia. x 11cm
富貴疊升（三）　Elevating Prosperity III
25cm dia. x 12cm

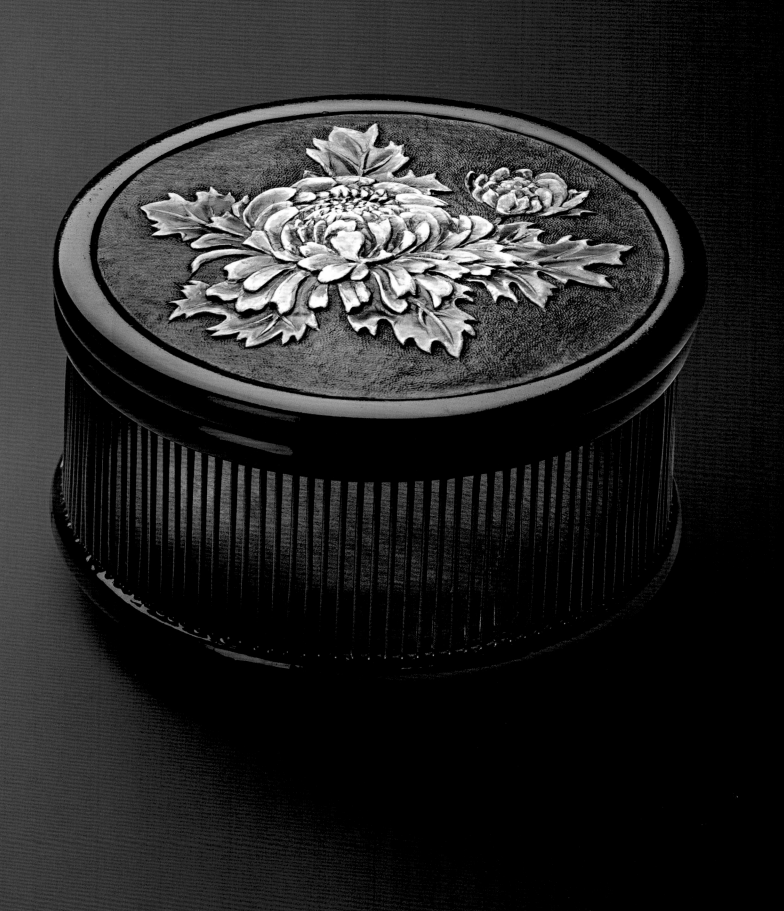

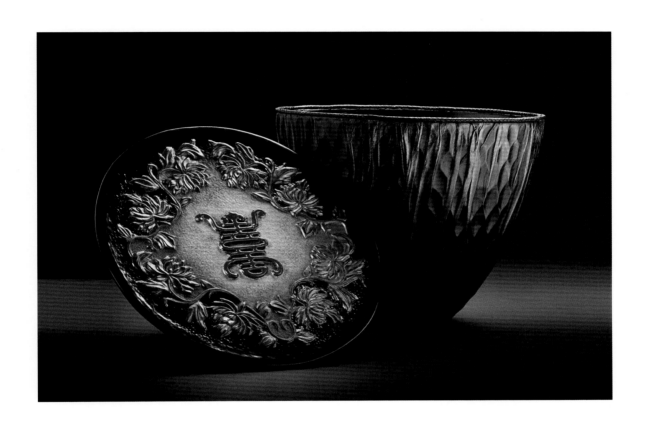

Long Live Fortune

The ribbon-shaped chrysanthemums embossed on the lid revolves around a life of good fortune and prosperity as illustrated by the Chinese characters, while the inverted cone barrel symbolizes a growing and flourishing life.

Concave scales were carved on the exterior of the barrel, depicting the gleaming sparks of life. The Chinese characters of good fortune and prosperity on the lid, along with the sheepskin that wraps around the barrel like flowing water, tells of the story of overflowing life and fortune…

壽吉滿溢

帶狀菊花浮雕紋樣，圍繞吉壽的人生，倒椎的外型，喻意著逐漸茁壯的生命。桶外鑿出內凹鱗片，刻畫著生命中的粼粼波光，吉壽的人生，與形如流水般包覆的羊皮，述說著壽吉滿溢的故事…

壽吉滿溢
Long Live Fortune
36cm dia. x 30cm

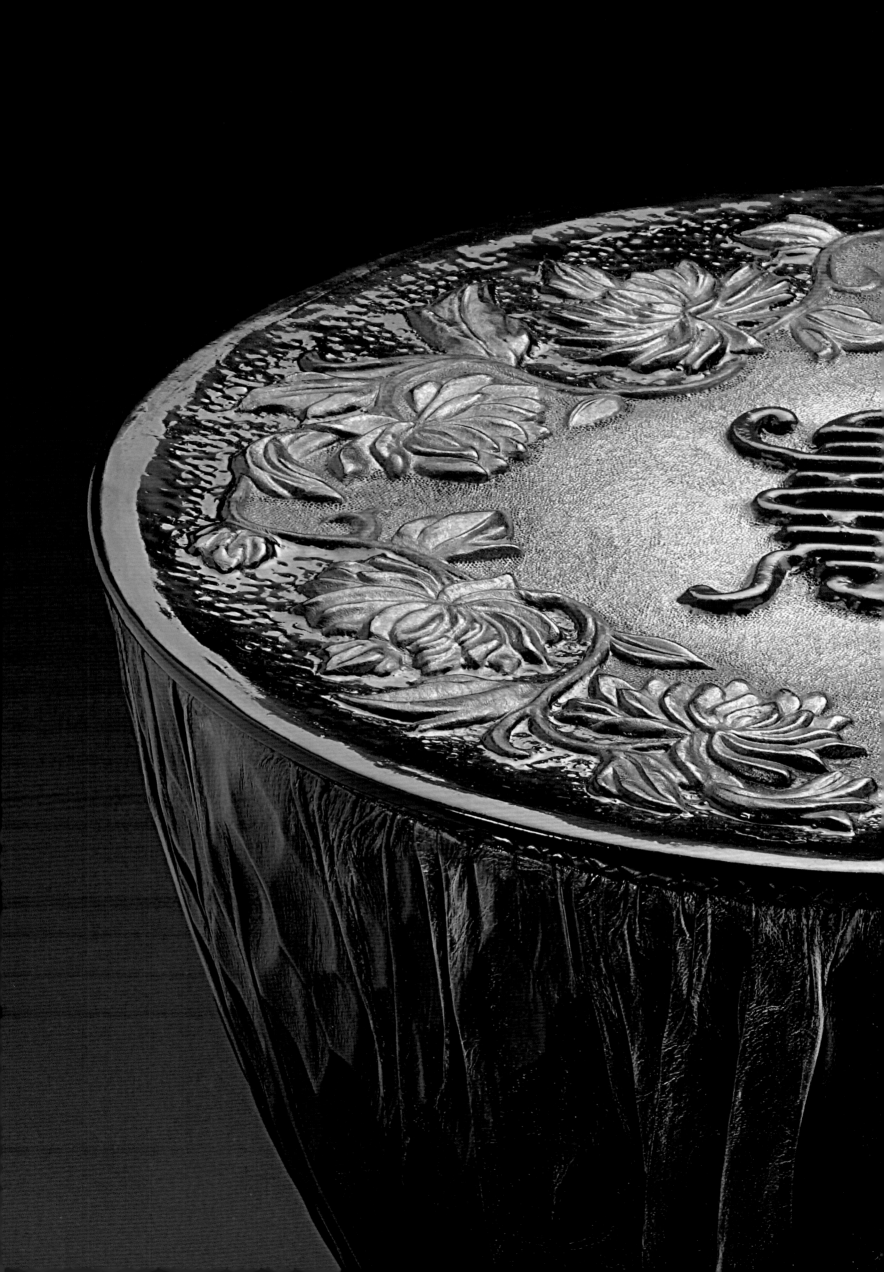

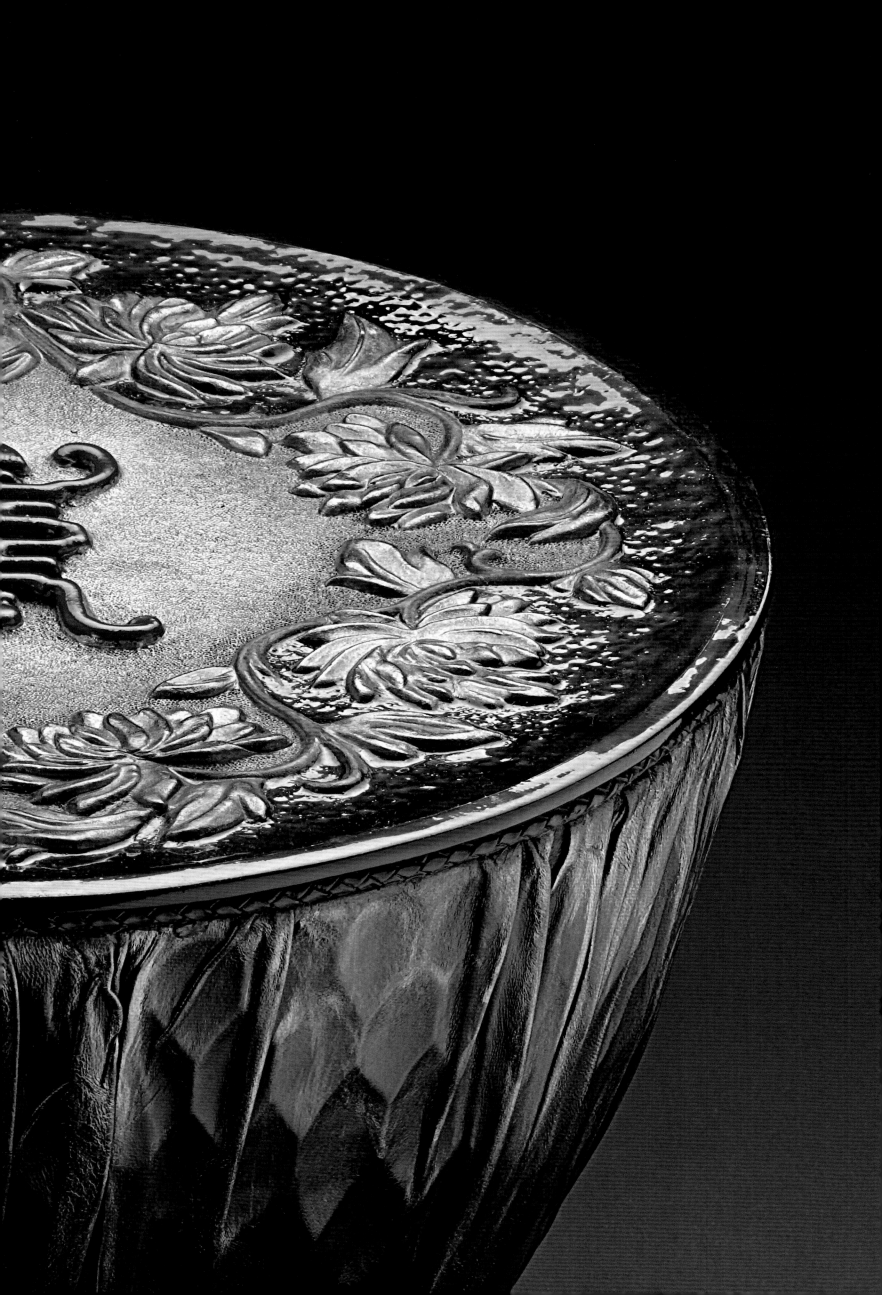

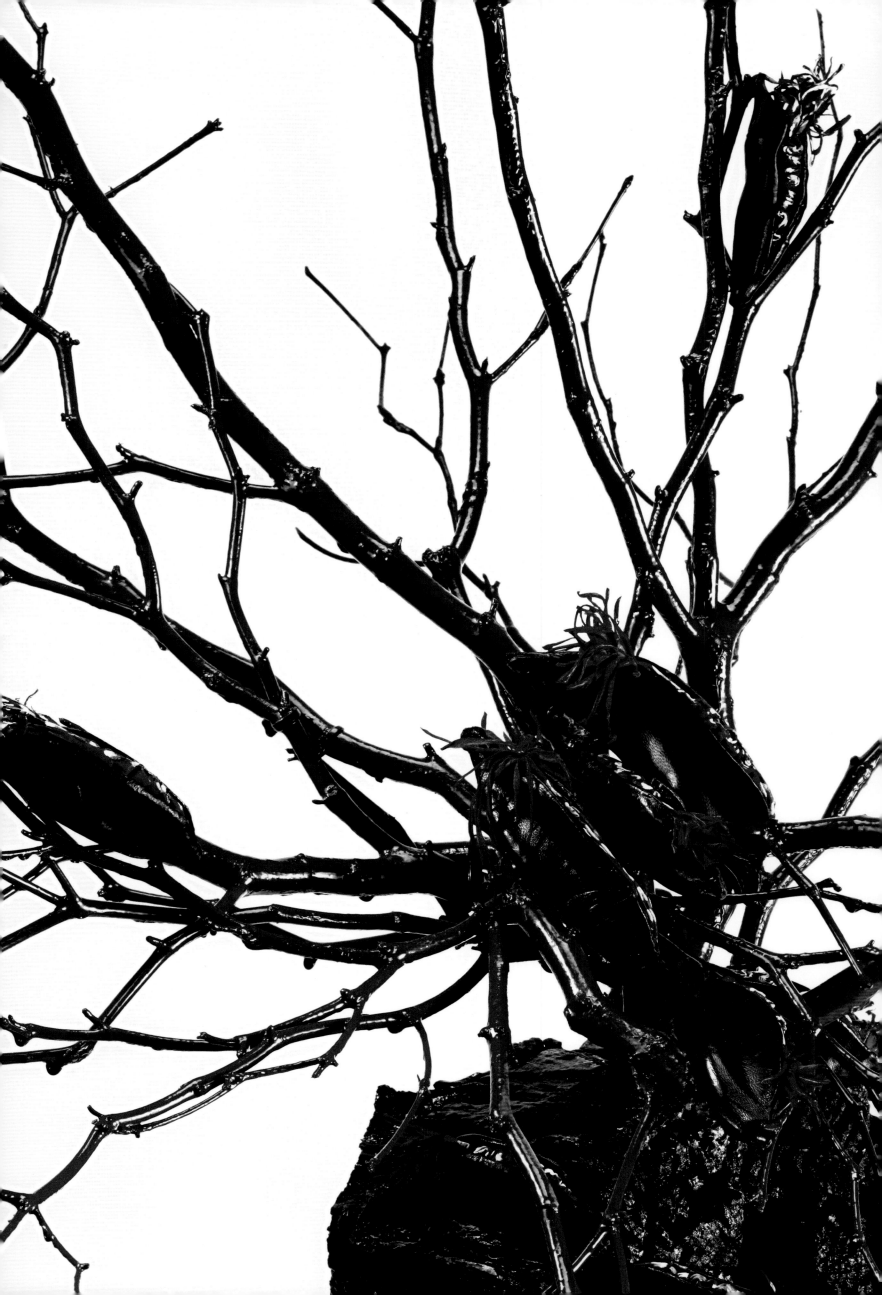

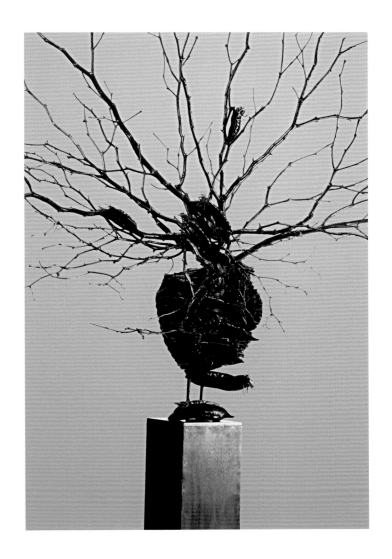

Migration

Through the interaction with nature, a unique ecological cycle is formed.

遷徙

與大自然互動，形成了獨特的生態循環。

遷徙 Migration
110cm x 150cm x 85cm

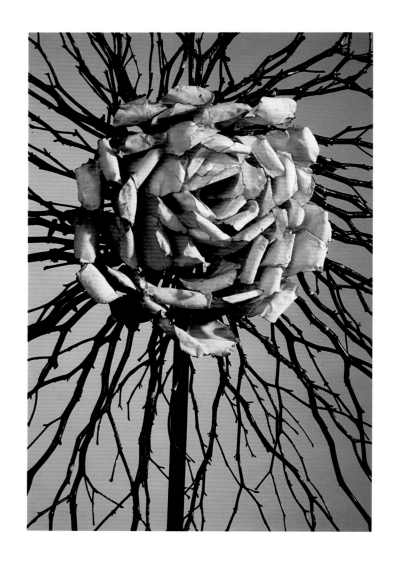

A Single Bloom vs. A Sea of Blossoms

One flower, one world, unique, and special. Blooming freely and splendidly, no judgement or comparison is needed. Spring is not a single bloom, but a sea of blossoms.

獨處與共榮

一花一世界，唯一且特殊；無需評論比較，自在燦爛開放。

一花獨放不是春，百花齊放滿園春。

獨處與共榮 A Single Bloom vs. A Sea of Blossoms
172cm x 230cm x 24cm

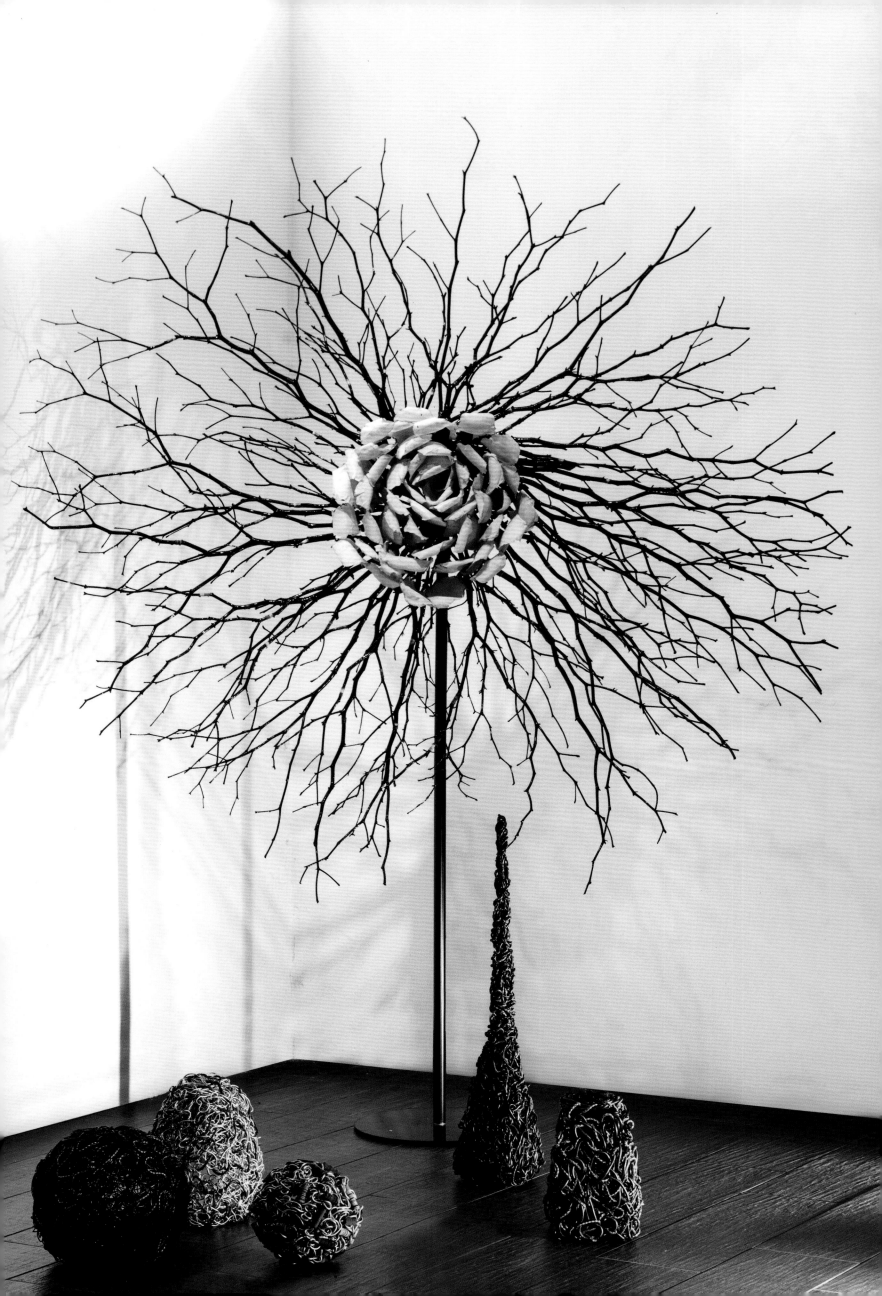

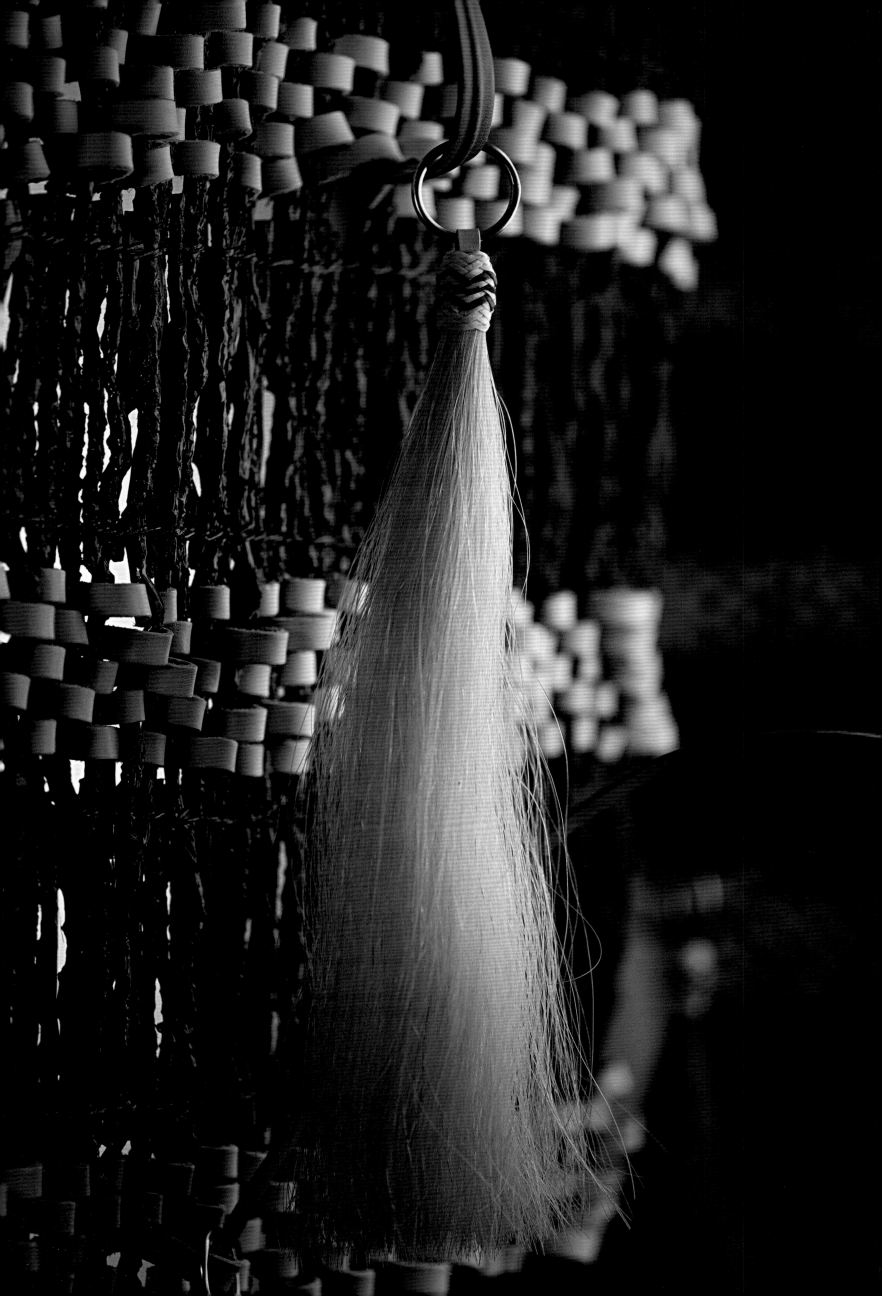

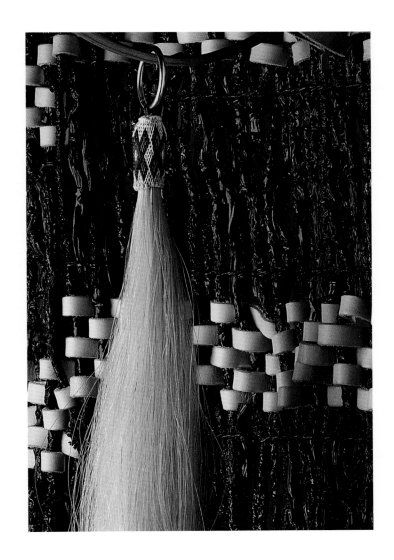

The Good Earth

Traveling through heavy winds and rainstorms, life withstands a multitude of trials and tribulations; despite the whitening earlocks, it can still thrive and grow.

大地

生命穿過厚重的風雨，歷經多重境遇的淬煉；
鬢髮雖白，仍能茁壯精彩。

大地　The Good Earth
330cm x 210cm x 60cm

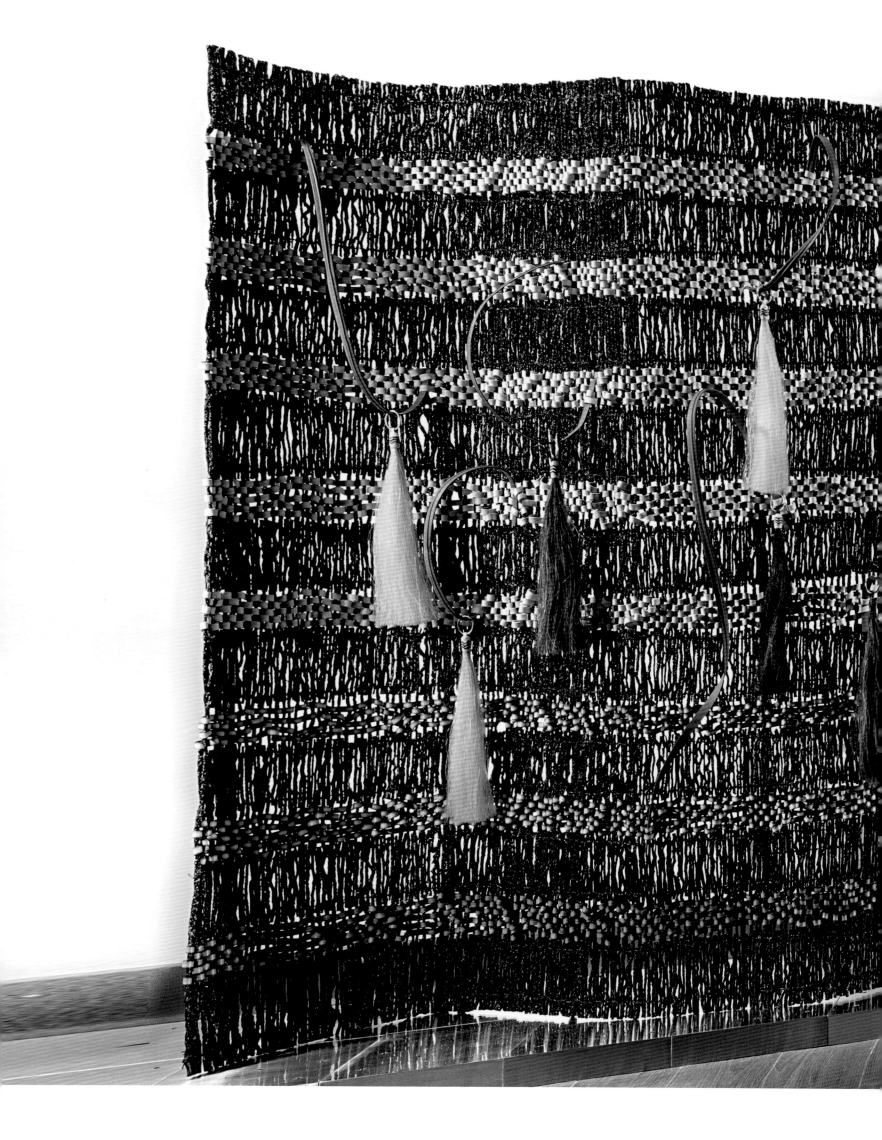

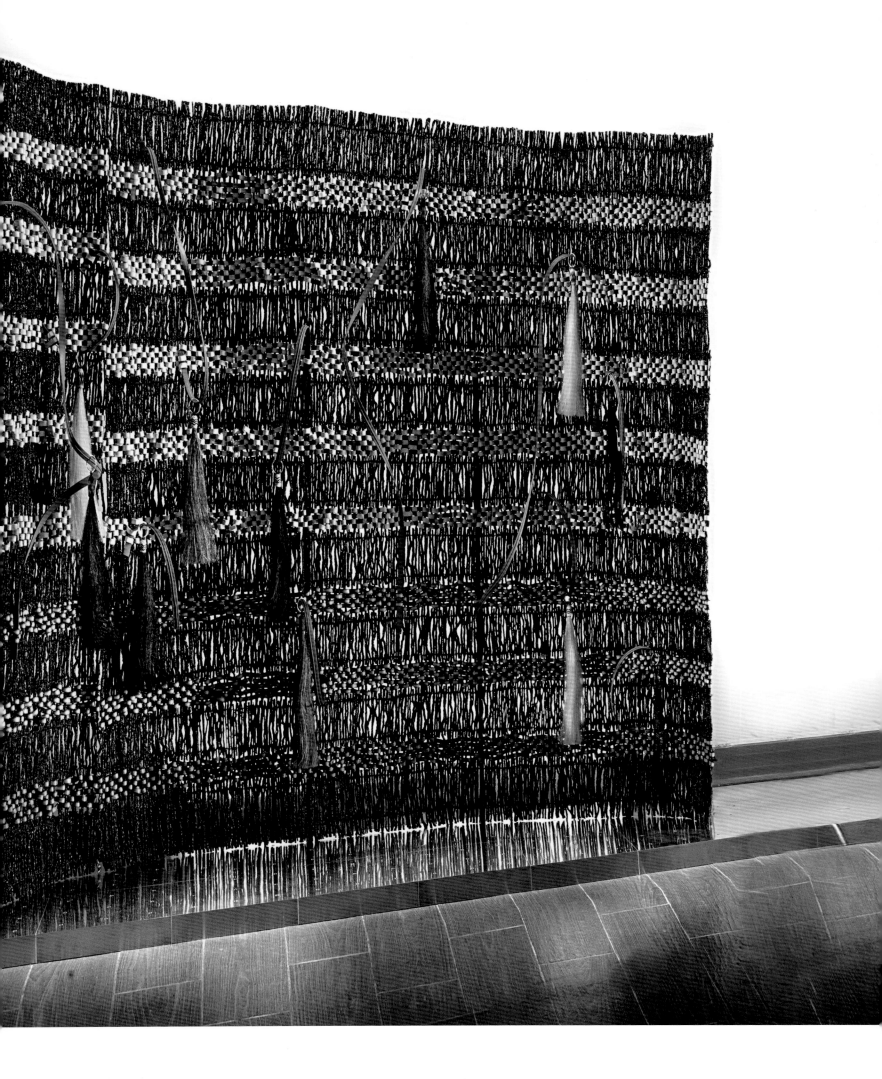

Inclusion &
Acceptance

When one is inclusive and tolerant toward others—
just like the mountains and oceans, one is more
capable of bearing great responsibility and
happiness.

山容海納

山海天地，厚德戴物。

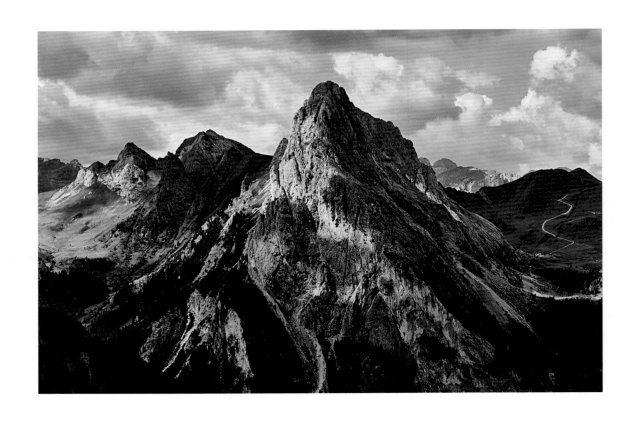

Still Waves

Standing against one another, the interconnected mountains are majestic and grand. The rises and falls of the hills resemble still waves that have been frozen in time. Since the dawn of man, the sharp outlines of the mountains have continued to challenge the ongoing conquerors.

凝固的波浪

相連的群山比鄰而立，氣勢磅礡。山頭起伏如凝固的波浪。尖銳的山型，互古以來挑釁著不斷前往征服者的神經。

凝固的波浪　Still Waves
53cm x 18cm x 64cm

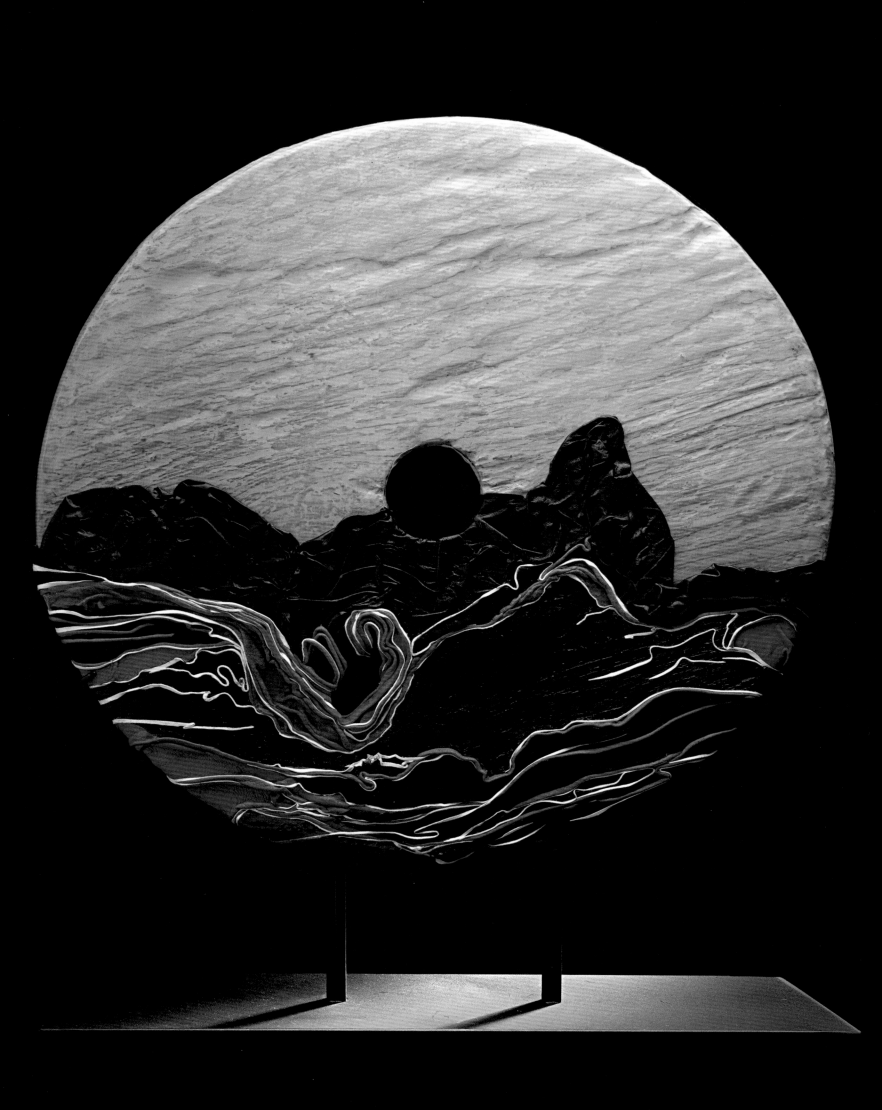

遠眺

遠眺那心中沒有的黑白純粹，無邊無際的海，分不清是天涯還是海角。它所擁有的，不僅僅是一種色彩，而是一種「生命」。

Looking from Afar

Overlooking the pure black and white that is absent in the mind, and the boundless sea where one cannot distinguish the end of the world from the edge of the ocean. What it has is not just color, but a form of "life."

遠眺　Looking from Afar
53cm x 18cm x 64cm

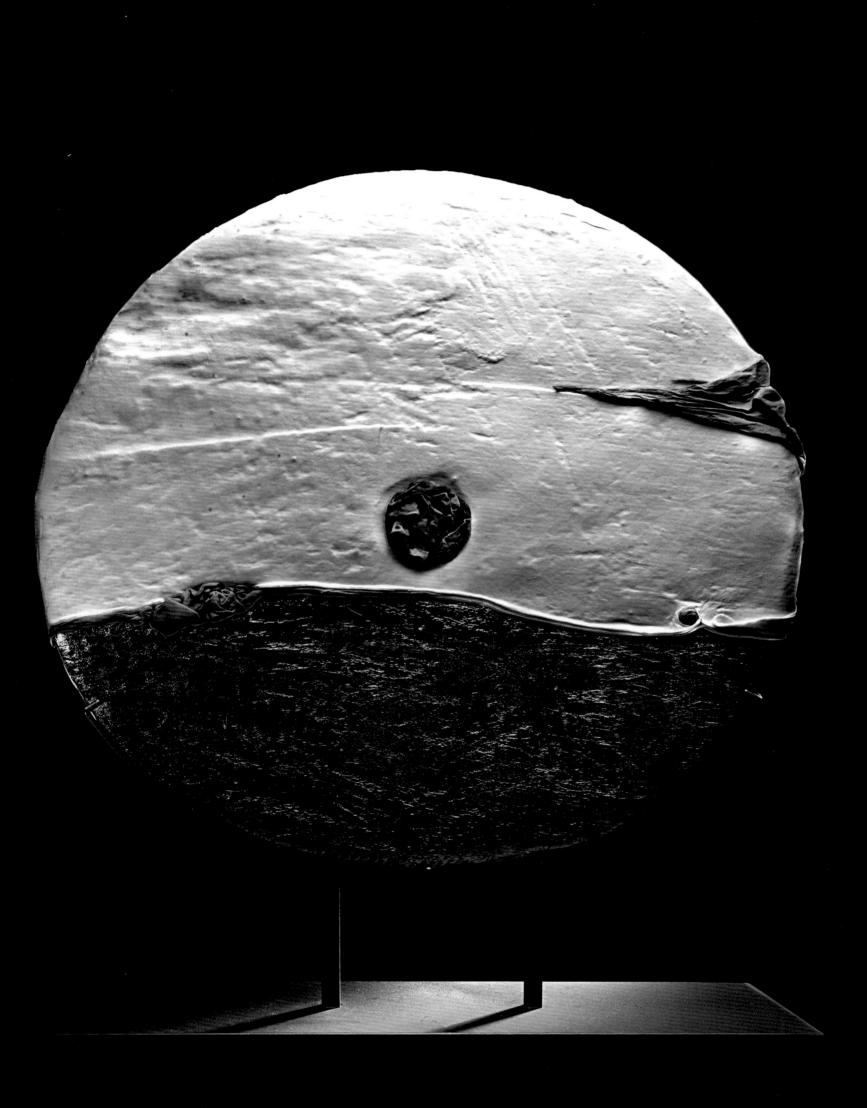

譯者/ **吳孝明**

曾 任 Apple、Google、Netflix 等 公 司 的
語言顧問，撰有《美國靈媒大師瑪麗蓮》、
《Angelic Force》等中英著作，現居矽谷。

Translator/ Sheree Wu

Sheree Wu was the Traditional Chinese consultant
for corporations including Apple, Google, and Netflix.
As the co-author of the bilingual book Angelic Force:
A Modern Medium 's Communication with the Spirit
World, Sheree lives in Silicon Valley.

出 版 者	馮斯蒂	
作 者	馮斯蒂	
總 編 輯	陳顥文	
翻 譯	吳孝明	
攝 影	張宏聲	
數 位	卿揚杰	
設 計	林佳霖	
電 話	02 8935 2024	
地 址	116 台北市文山區辛亥路四段 101 巷 147 號	
網 站	www.sdi-leather.com	

Publisher	Szu-Ti Feng
Author	Szu-Ti Feng
Editor-in-Chief	Hao-Wen Chen
Translation	Sheree Wu
Photography	Hung-Sheng Chang
Digital	Yang-Chieh Ching
Design	Jia-Ling Lin
Telephone	02 8935 2024
Address	No. 147, Ln. 101, Sec. 4, Xinhai Rd., Wenshan Dist., Taipei City 116 , Taiwan
Website	www.sdi-leather.com

出版日 (首刷) First Edition：Dec. 2021
ISBN：978-957-43-9262-9
定價 Retail：TWD 2400

紋革創生
LEATHER ART: REGENERATION

蒂革工舘官網　　　　頤坊皮藝官網

國家圖書館出版品預行編目 (CIP) 資料

紋革創生 Leather art: regeneration
馮斯蒂作 .-- 臺北市：馮斯蒂 , 2021.12
128 面 ； 長 35 寬 23 公分
中英對照
ISBN 978-957-43-9262-9(精裝)
1. 皮革藝術 2. 作品輯
936　　　　　110014600